PIT BULL
HEROES

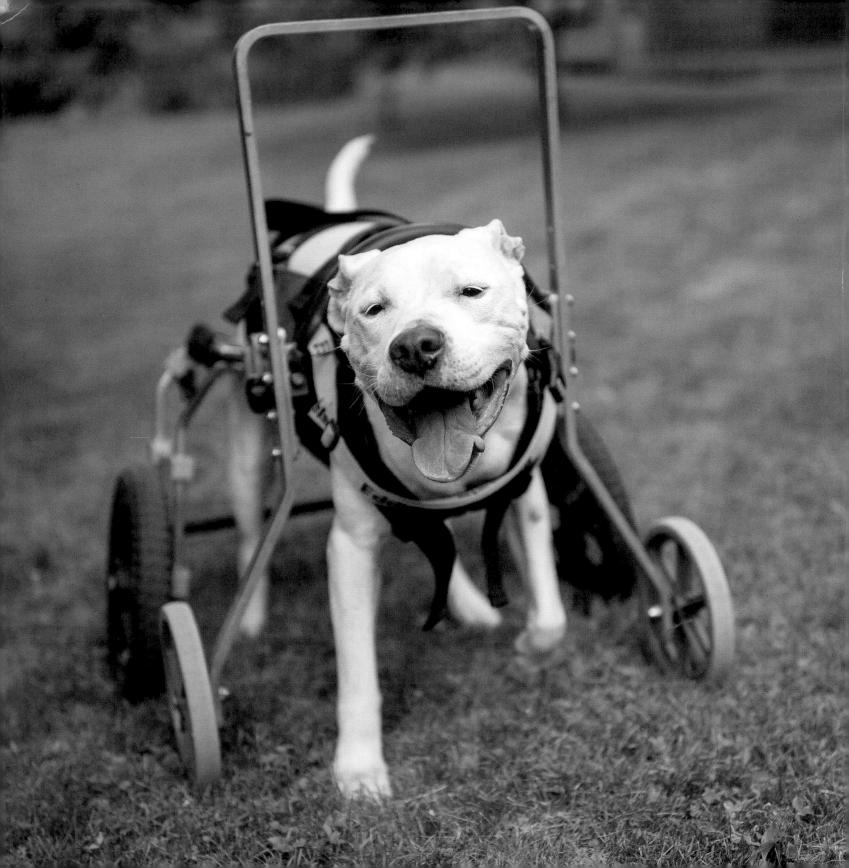

PIT BULL HEROES

49 Underdogs with Resilience and Heart

GREG MURRAY

GIBBS SMITH
TO ENRICH AND INSPIRE HUMANKIND

First Edition
23 22 21 20 19 . . . 5 4 3 2 1

Published by
Gibbs Smith
P.O. Box 667
Layton, Utah 84041

1.800.835.4993 orders
www.gibbs-smith.com

Designed by Rita Sowins / Sowins Design
Printed and bound in China.

Gibbs Smith books are printed on either recycled, 100% post-consumer waste, FSC-certified
papers or on paper produced from sustainable PEFC-certified forest/controlled wood source.
Learn more at www.pefc.org.

Library of Congress Cataloging-in-Publication Data
Names: Murray, Greg, author.
Title: Pit bull heroes : 49 underdogs with resilience and heart / Greg Murray.
Description: First edition. | Layton, Utah : Gibbs Smith, [2019]
Identifiers: LCCN 2018058563 | ISBN 9781423650447 (hardcover)
Subjects: LCSH: Pit bull terriers--Anecdotes.
Classification: LCC SF429.P58 M87 2019 | DDC 636.755/9--dc23
LC record available at https://lccn.loc.gov/2018058563

ISBN: 978-1-4236-5044-7

To all the animals in shelters looking for their forever humans.

More than 4,000 of them are euthanized daily in the US alone. Help bring that number down by adopting, fostering, volunteering, donating, advocating, and educating.

CONTENTS

FOREWORD
A LOVE LETTER TO GOOD DOGS AND THEIR DEFENDERS

I met Scarlett at the pound in Gary, Indiana. She looked like a dull, brown sack with nothing but bones inside. She didn't have the strength to climb into my car. So, not knowing the first thing about this sorry-looking dog I'd just sprung, I scooped her up and arranged her on the passenger seat. As I pulled out of the pot-holed parking lot, I handed her a big, meaty treat. Holding it in her teeth, she glanced at me for a long moment, then—no kidding—she looked back at the dilapidated building and growled. Good riddance! After a trip to the vet, where she was diagnosed with severe malnutrition and an incurable type of anemia, I brought her home to my condo on the South Side of Chicago, which I shared with my partner, Matt, our tough little cat, Sushi, and our beloved resident pit bull, Beatrice. For days Scarlett recuperated in our guest room, lying beside me as I wrote my doctoral dissertation in social work. Her pressure sores began to heal, she steadily gained weight, and she learned that she was safe, perhaps for the first time in her life. She became friends with Beatrice, who showed her how civilization worked: You potty outside, you play with this ropey-rope, you watch movies on the sofa, and the human people feed you and make a big deal about how cute you are.

Scarlett, like so many of the pit bulls we fostered through Chicagoland Bully Breed Rescue, had what seemed an almost supernatural sensitivity to human feelings. Once, as Scarlett slept on her velveteen dog bed in the corner of the living room, my sister-in-law began to cry. To our surprise, this apparently sleeping, terminally ill dog with no reason at all to trust humans leapt onto the sofa beside Mary and gently licked her tears away.

As Scarlett's anemia inevitably worsened, Beatrice donated blood and stuck by her tired friend. But in the end, the best we could give her was four months of the good life—four months that she so totally deserved. Being a part of what I've begun to call the Pit Bull Movement can break your heart. We have seen acts of abuse and

neglect that haunt our dreams. Being a part of this movement means looking squarely at the profound, seemingly endless injustice experienced by a group of dogs that many Americans have written off as monsters. Sometimes it also means ruined carpets or nibbled cell phones, a crate in your kitchen, endless fundraising, weekends spent doing home visits with potential adopters, or educating police departments or city governments about the plight of "pitties." It often means dealing with the ignorant and harmful prejudices of people who believe you can determine the content of a dog's character by the shape of its head or the shine of its coat.

But being a part of the Pit Bull Movement has also put me in touch with some of the world's toughest, kindest people—folks who, on a shoe-string and out of a deep commitment to making the world better for people and dogs, keep on doing the almost impossible. They are my heroes. They go into the back rooms of high-kill public shelters to make gut-wrenching decisions

about which lucky pittie will find her way into their one available foster home. They deliver donated kibble to dog owners who are homeless and arrange for their dogs to be spayed or neutered. They meet strangers under the "L" tracks to pick up sick and injured dogs, no questions asked. They comb the terrifying online pet-for-sale ads trying to prevent dogs from falling into the hands of dogfighters. They show up at city council meetings all over the country to advocate for just and effective animal welfare laws rather than ineffective breed-discriminatory legislation. And they lead by example, through responsible dog ownership and by helping their own pitties become ambassadors of the breed.

As a social worker, I am part of a profession with a long (if imperfect) history of fighting for social justice. From my point of view, I can't help but see the maltreatment of pit bulls and the discrimination against them as bound up with the same social forces that sustain racism and economic injustice. As scholars like Erin C. Tarver and Bronwen Dickey have shown, pit bulls have become associated with crime, poverty, and people of color—an association that harms both dogs and people of color by perpetuating a false stereotype that both are dangerous. In reality, pittie owners are people of all races, ethnicities, genders, and socioeconomic backgrounds. So are the rescuers and advocates working on their behalf. Few of the pit bull–type dogs found in America's shelters have ever been involved in dogfighting, and ongoing research continues to show that pitties in shelters pass temperament testing at higher rates than many other well-loved breeds. I've come to hear in arguments for "breed-specific legislation" not-very-subtle racism and classism. Maybe it sounds simple, but I want for pit bulls something I want for myself: To be judged by my own actions in the sometimes-difficult circumstances of my life, to be known without prejudice. The goofy, affectionate, brave, resilient dogs Greg Murray has photographed for this book have been lucky enough to be seen in this way.

So, when I look into the eyes of a pit bull, I don't make assumptions. Instead, I find myself silently asking, "Who are you? Show me who you are." Finding out has been one of the great joys of my life.

Eevie Smith, Ph.D.

To read more, see "Beatrice, Kimberly & Stilton" on page 76.

INTRODUCTION

As someone born and raised in the Cleveland, Ohio, area in the 1980s and '90s, I learned to root for the underdog. Whether it was our sports teams' championship drought, the over-polluted Cuyahoga River catching fire in 1969, or the disparaging nickname Mistake by the Lake, we always seemed to be crawling out of a hole.

While things have improved immensely over the past decade, being part of an underdog city has unquestionably played a significant role in my life. Along with my upbringing and a community service–heavy education, being a "Clevelander" helped propel me into pit bull and rescue animal advocacy.

I started volunteering as a photographer with the Cleveland Animal Protective League and other Cleveland-area rescue organizations in 2012. When I began taking photos of the dogs to help them get adopted, I learned that the majority of them were designated as "pit bulls." Other than the way they looked, with their beautiful blocky heads and the fact that there were a lot of them, I didn't see pit bulls as being any different from the other dogs waiting to find their forever humans. I grew up with dogs and other animals as beloved household pets; to me, all animals were unique individuals.

In 2014, my wife, Kristen, and I decided to move from Cleveland to Lakewood, Ohio (the first suburb west of Cleveland). I grew up in Lakewood and was beyond excited to be moving there with Kristen. It's on the shores of Lake Erie, walkable to countless great restaurants and local hangouts, a ten-minute drive to downtown Cleveland, and it's one of the most densely populated cities in the country. This population density gives it a real community feeling—it's hard not to get to know your neighbors.

As Kristen and I began our apartment search for ourselves and our two rescue dogs, Leo the mutt and Bailey the black cane corso mastiff, we only had one concern: the

way Bailey looked. In 2008, the city of Lakewood implemented a ban on pit bull-type dogs. To some, including trained professionals, Bailey could be perceived as a pit bull-type dog. We didn't want her to be discriminated against and possibly kicked out of Lakewood after we moved, so I emailed a Lakewood animal control officer a photo of Bailey and asked if she would be allowed to live in the city. Keep in mind, Bailey was a well-behaved dog. Emailing a photo for approval seemed ridiculous and sad to me. Although we ended up receiving the approval, it left a bad taste in my mouth. Why would a city ban a dog based only on the way it looks? It seemed to fly in the face of safety, equality, and common sense. The policy countered Lakewood touting itself as a "progressive" city on its website.

The four of us moved to Lakewood and vowed to be part of repealing Lakewood's pit bull ban. Long story short, a group of amazing advocates numbering in the hundreds started a well-planned push to end the ban in early 2017. A few months into the drive, a pit bull rescue named Charlie came into the picture. (See page 129 for his story.) After ten months of packing council meetings, protesting in front of Lakewood City Hall, making local and national news on a regular basis, conducting countless public records requests, bringing in the experts, canvassing to vote out two pro–pit bull ban council members, filing a lawsuit, and simply not giving up, the ban ended on April 2, 2018.

Almost ten years to the day after the ban was implemented, Lakewood, Ohio, abolished it and instead implemented strong, objective, and common sense ordinances proven to impact safety when enforced consistently and fairly.

From 2014 until today, I have fallen in love with pit bull-type dogs. They've become my favorite kind of dog to photograph. At this time in our history, pit bulls are the underdogs. It used to be the Doberman pinscher, rottweiler, or German shepherd. In some cases, those three are still discriminated against. But right now, it's the pit bull who gets the worst rap, partly thanks to the resurgence of dogfighting in the 1980s. Because of their underdog status, they are my passion when it comes to my photography and rescue animal advocacy.

We're all guilty at one time or another of being afraid of something we don't understand or attaching a stereotype to something because of a news story we saw. Physical characteristics that dogs, or humans for that matter, are born with are not and will never be a predictor of behavior. Discrimination of any type should not have a home in our world.

Dogs are my heroes. And because of my experience from 2014 until now, it's important for me to share with you pit bull-type dogs who are heroes, too. They help us as therapy and service dogs. They protect our communities as police K9s. They make us feel better when we've had a bad day. They don't care what we look like. When terrible events happen, they

always manage to comfort us. In many cases, dogs have every reason to give up on humans because of the abuse that they have endured. Yet they still forgive and welcome us as their forever humans. I wish every human had the qualities that many dogs have: forgiveness, love, resilience, humor (who doesn't enjoy a farting or snoring dog?), bravery, loyalty, playfulness, and acceptance.

I'm under no illusion that all dogs are perfect. All dogs, no matter what they look like, can bite. That is a fact. All dogs, no matter what they look like, can be amazing family pets. That is also a fact. All dogs are unique individuals and we must manage them appropriately based on their individual characteristics. As advocates, we need to champion companion pet safety and management.

Many of the stories in this book might anger you or make you sad when you start reading them. I hope they do (I'd be concerned if they didn't). Just know these dogs are in good homes now. They impact people in a positive way every day; they defy their negative stereotype, helping to get other pit bull–type dogs adopted; and they inspire their humans to make this world a better place. You might cry at times, but I can assure you that you'll smile and laugh plenty.

Be kind, educate, volunteer, donate, advocate, and consider rescuing a pit bull hero next time you're looking to add to your family.

Greg Murray

APOLLO

Apollo was abandoned and sent to a Washington State shelter in early 2015. After six months at the shelter, he was deemed to have too much energy for anyone to adopt him; the plan became to euthanize him. Before doing so, the shelter reached out to a narcotics K9 trainer named Barbara and asked her to evaluate Apollo. After some exercises she determined he would be great at narcotics detection work, so they began training together with the hope that Apollo would be hired on by a police department.

Around the same time, Jamie, a detective with the Tukwila, Washington, police department asked his chief if the department could bring on a narcotics detection dog. A pilot program was approved, and Jamie was given six months after finding a qualified narcotics canine to see what the dog could find. If Jamie and the dog didn't meet expectations, the city would sell the dog to him for one dollar, and Jamie would go back to working the streets as a patrol officer.

Jamie had one particular request before beginning his search for a narcotics dog. He told the chief that he wanted a pit bull–type dog because the 2015 narcotics K9 of the year for the NYPD was a rescued pit bull. Jamie wanted the pilot program to be a success and knew he needed the best type of dog for the job.

Jamie connected with Barbara a few weeks later during his search, and she told him about a pit bull available that had been in her shelter for almost a year. She put a significant amount of time into training Apollo to get him adopted, but police departments were still passing over him because of the way he looked. By this time, Apollo

APOLLO

was trained to detect heroin, methamphetamine, and cocaine. Barbara told Jamie that Apollo was a star pupil. Jamie was convinced and began training with Apollo shortly after that. Barbara was right. Apollo graduated first in his class in November 2016.

By the end of the six-month pilot program in May 2017, Apollo and Jamie had assisted in finding more than $300,000 in cash and several pounds of narcotics at the USPS and various private parcel carriers. The social media officer at the department asked Jamie to take a photo of Apollo and do a write up about him for their Facebook page to celebrate the successful end of the pilot program. The post received more than 35,000 likes and thousands of shares. Apollo went viral! Not only did Apollo make appearances on every news station in the Seattle area, but news sites from around the world also featured him.

That summer, Apollo became an official member of the Tukwila Police Department and a permanent member of Jamie's family. In one year, Apollo assisted them in cash seizures adding up to one million dollars and in detecting sixty pounds of narcotics.

Apollo works with Jamie four days a week for ten hours a day. Even when they're not on duty, they go everywhere together and are at each other's side almost 24/7. Apollo is also attached to Jamie's seventeen-year-old son. He and Apollo can often be found sleeping in his bed or lying on the couch together. He loves to take Apollo on long walks and show him off to his friends.

Jamie and Apollo had only done one event together before Apollo went viral in May 2017. After that, they received several requests a week to attend events in the Seattle area and never turned anyone down. They have been to numerous meet and greets where dozens of young children have swarmed Apollo.

Sometimes it takes Jamie and Apollo extra time to get to their office because people want to stop them and say hello. How do they know Apollo is coming? Jamie says Apollo always barks because he knows that will get the attention of people in the area. People from other departments in the building and other officers come to visit him too. Apollo enjoys getting his rubber bone out so he can play tug-of-war with his visitors. Too much attention is never a problem for him.

Apollo is a determined and friendly dog, which makes him an excellent fit for his job. He loves kissing everyone on the face and making new friends. He understands his role and knows when it is time to get to work. The City of Tukwila and Jamie are lucky to have such an exceptional dog, friend, and partner.

"By the end of the six-month pilot program, Apollo and Jamie had assisted in finding more than $300,000 in cash and several pounds of narcotics."

CHAD

Six puppy siblings were rescued from the streets of Chester, Pennsylvania, in the fall of 2012 when a concerned passerby saw a man trying to sell them from the street corner. The litter was taken to the Providence Animal Shelter to get the care they needed to be adopted out. A few weeks later, a girl named Danielle eagerly called her mother to tell her that she had visited the shelter and found a beautiful brindle puppy named Brewsky, one of the six rescued puppies and the only one with white paws. She was leaving for college soon and wanted her mother, Chrissy, to have a furry companion when she left. Danielle and Chrissy visited the shelter together and came home with Brewsky that evening. They renamed him Chad.

Chad was a happy, friendly, and loving puppy. He was comfortable around children, loud noises, and other dogs. Chrissy had a feeling that he had a lot to give to the world, so she enrolled him in a basic obedience class to train and socialize him. To say that Chad did well is an understatement. He did exceptionally. Passing the basic obedience class enabled him to enroll in the advanced courses, all of which he completed by the age of one. The dog trainer saw a lot of potential in Chad. Not only was he learning very quickly, but the trainer also noticed his amiable and calming disposition. He asked Chrissy if she would be interested in training Chad to become a therapy dog. After doing some research on the process, Chrissy decided to move forward with training.

There is a lot of testing involved to become a Canine Good Citizen (CGC) and therapy dog. Making a single error during the tests is an automatic fail and requires starting over on another day. That is exactly what happened to Chad after passing

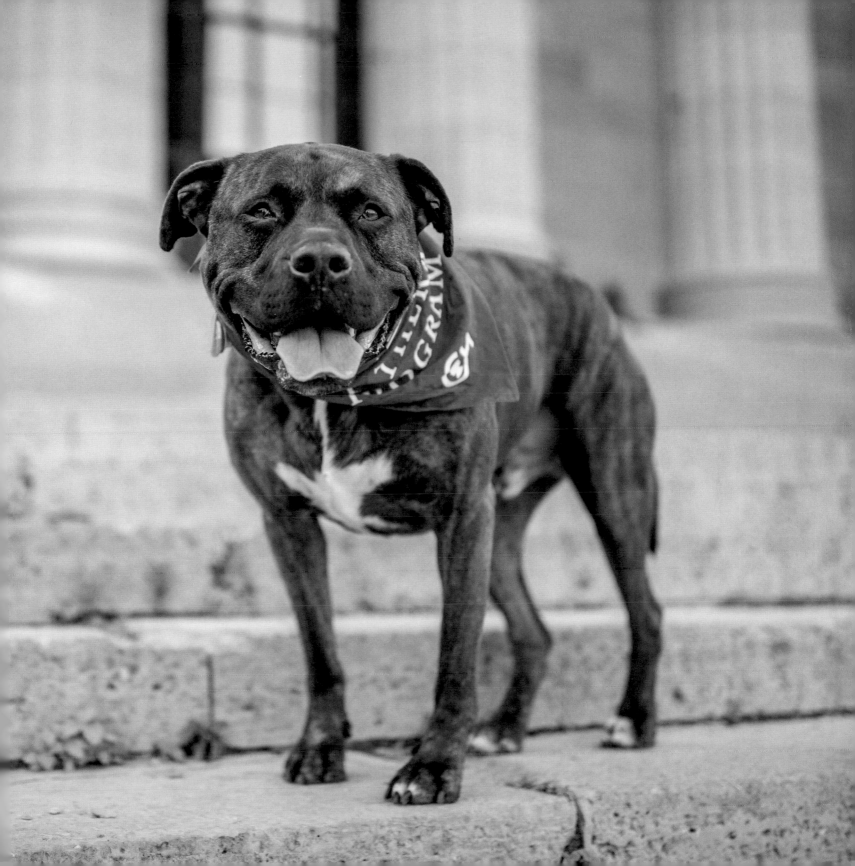

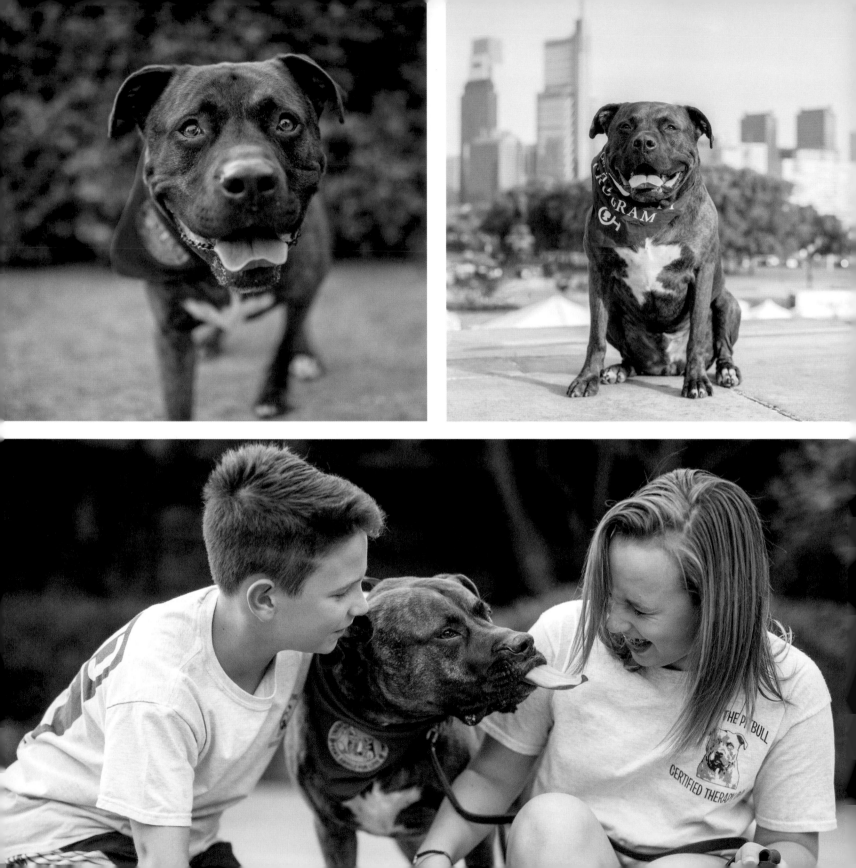

his CGC certification. He failed his first therapy dog test by slipping up with the "treat test." On his second try, Chad (led by Chrissy) successfully walked past five sausage treats purposefully placed on the floor to distract him. After succeeding at that test and the other requirements, he earned his therapy dog certification in April 2014.

Chad began his therapy dog duties with Chrissy immediately. They spent time in local nursing homes and assisted living facilities where the presence of a dog has been shown to help reduce stress and depression, and even defuse some of the common symptoms associated with conditions like Alzheimer's disease and dementia. Everyone loved his presence.

Chad's success with the elderly encouraged Chrissy to seek new opportunities for him to help others as a therapy dog. Chad had always done well around children. He was even more careful around them than with adults, often licking their hands, feet, and faces when he met them. Because of all the work Chad and Chrissy were doing in the community, they became known to many, and one day Chrissy was approached by the program coordinator of the pet therapy program at Children's Hospital of Philadelphia. They knew Chad loved being around children and felt that he would be an excellent fit for the program at the hospital. Chrissy and Chad agreed.

The screening process was rigorous. After the official interviews, Chad was medically and behaviorally screened at the University of Pennsylvania. Chrissy had to go through a background check, FBI fingerprinting, child abuse clearances, and health clearances. Once those were complete, Chad and Chrissy went to an orientation and received hospital-specific training. In November of 2014, Chad was accepted as the first "pit bull" in the pet therapy program at Children's Hospital of Philadelphia.

In 2015, Chad was nominated for the American Kennel Club Humane Fund Award for Canine Excellence in recognition for his services to humankind as a therapy dog. In 2016, he was honored with the Ginger Award from his alma mater, the Delaware County SPCA. This award is given yearly to an exemplary pit bull–type dog who serves as a breed ambassador in their community.

Today, Chad and Chrissy regularly visit schools, colleges, hospitals, nursing homes, anti-bullying meetings, and the Domestic Abuse Project of Delaware County to share his love and comfort to anyone in need. They also attend local events that educate communities about the stigma that is placed unfairly on dogs like Chad because of their appearance. Chrissy and Chad teach responsible dog ownership, explain what breed discriminatory laws are, and increase awareness of pit bull–type dogs as therapy and service animals.

Chad has been giving back since he was a puppy and looks forward to helping the people that need him most.

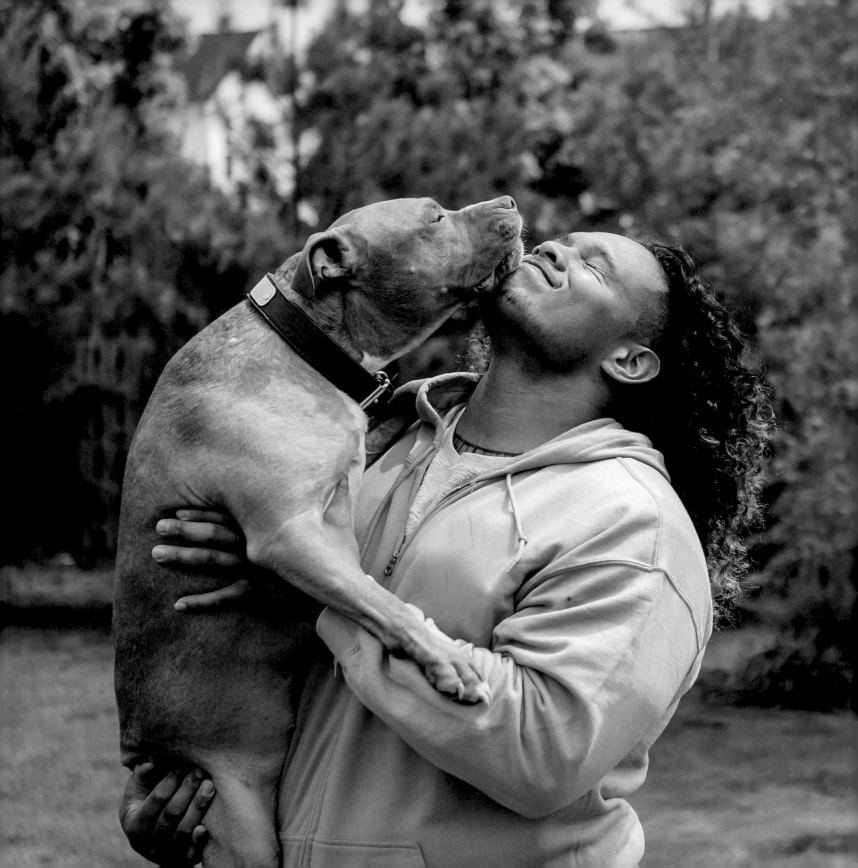

MONI

Tragedy struck Danny Shelton's family in 2011 when his brother was murdered. Danny witnessed the incident and was the one to subdue the man who killed his brother. A high school senior at the time, Danny had already committed to play football at the University of Washington the following year. He almost quit the sport altogether after the loss of his brother, but his family urged him to continue, and so he did.

His first two years in college weren't easy. Danny struggled with anger issues, on and off the football field, and was also getting caught up in the party scene at school. These issues had a negative impact on his academic and athletic performances.

After his sophomore year, Danny decided it was time to take control of his life and move in a positive direction. He began to take football and school more seriously, and felt that some responsibility would give him much needed confidence and stability. That responsibility came in the form of a pit bull puppy named Moni. He had always wanted a pit bull as a kid because many people view them as scary, when in fact they're kind and loyal dogs. Danny saw himself in a similar light: big and different looking, but friendly and dependable.

Now that Danny had a life other than his own to take care of, he couldn't waste his time partying or allow his anger to take control. His priorities were his girlfriend, Mara; his pup, Moni; school; and football. Danny's coach and teammates witnessed him transition from an angry, immature kid to a mature man who helped lead the team. Much

of the campus got to know Moni because Danny took her everywhere he possibly could. He became a happier and more invigorated person than he was before Moni entered his life.

One dog wasn't enough. Danny and Mara brought Juicy the Husky into their home during Danny's senior year at Washington. Now Danny had two lives he was responsible for, in addition to his schooling and football. The dogs brought him joy and helped him to grow personally over his time in college—he wouldn't have been able to do that without them. Because of the positive changes Moni and Juicy prompted in his life, Danny was selected in the first round of the 2015 NFL draft.

Moni has inspired Danny to get involved with shelters because many of them have an abundance of pit bull–type dogs, just like Moni. He has given much of his time and money to help rescue organizations in each city where he's played professional football. While playing for the Cleveland Browns, Danny dressed up as Santa two years in a row to deliver thousands of dollars worth of supplies and food to the Cuyahoga County Animal Shelter.

Today, Moni is no longer just a big sister to Juicy the Husky. Juju and Mojo have joined the family and the four of them are often collectively referred to as the Furry Sheltons. Together, the four of them spend Sundays with Mara watching Danny play football. They love wrestling in the living room and the four even tolerate Mara and Danny dressing them up in holiday-inspired outfits.

Moni is a joyful, quirky, and playful pup who always keeps Mara and Danny on their toes. She doesn't believe in a conventional use of stairs. Instead of walking down them, she can often be found sliding down the staircase from the second to the first floor in their home. If you go to their house for a visit, she might welcome you at the door with one of Danny or Mara's shoes. While Moni loves meeting new people, she is frequently last to be greeted because she's a pit bull. Once people get to know her, however, she is oftentimes the favorite of the pack.

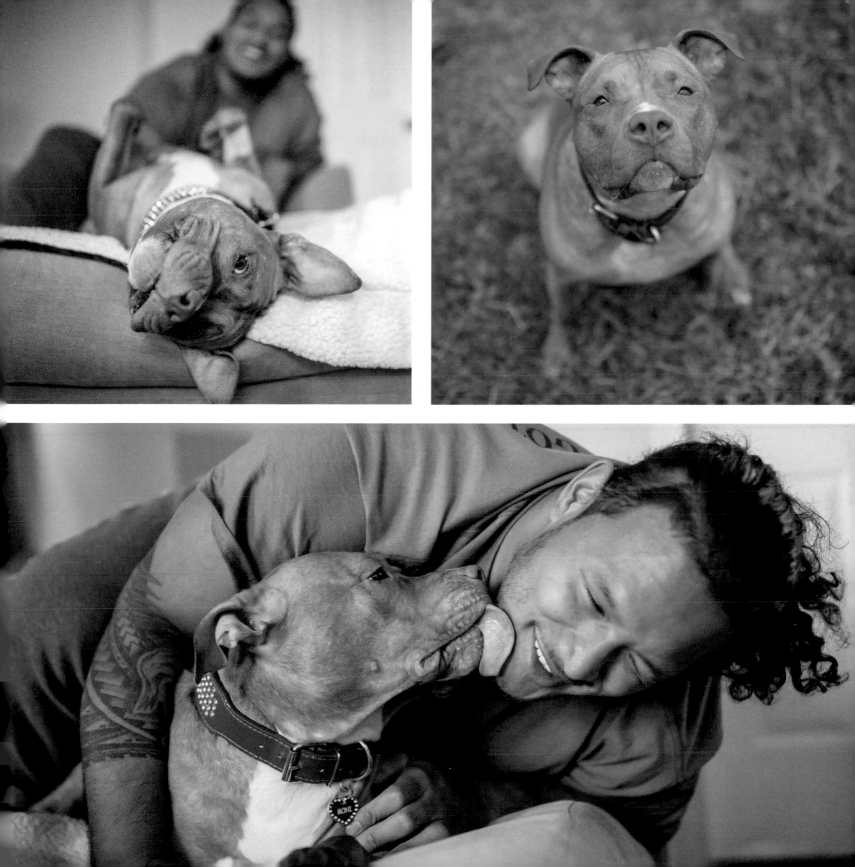

MEL

Tom and his wife, Tamara, visited the Yonkers Animal Shelter in 2010 to see a dog they had seen on Petfinder.com and were interested in adopting. After spending some time with the dog, they realized that he wasn't the right fit for them. A shelter employee then suggested that they take a look at a dog named Mel.

Mel was picked up as a stray in Yonkers eight months prior. He was house trained, very friendly, and walked well on a leash. Tom kneeled down during a test walk at the shelter and Mel immediately rested his head on Tom's leg. Tom and Tamara decided right then and there to make Mel part of their family.

Two years after bringing Mel back to their home, Tom and Tamara noticed he was having some coordination and balance issues. Mel's dog walker also mentioned that he had fallen over while they were on a recent walk. They took Mel to the vet where the results of testing were inconclusive. When Mel's coordination and balance continued to worsen, they took him to a neurologist where he was diagnosed with cerebellar ataxia. This condition often results in a decline of coordination, stability, and motor function control. While there is no cure for cerebellar ataxia, there is no pain from it either. Luckily for Mel, Tom and Tamara were willing to do anything necessary to help with his condition.

Six months after the diagnosis, Mel's parents began searching online for dog wheelchairs. They found a company in Massachusetts that produces custom chairs,

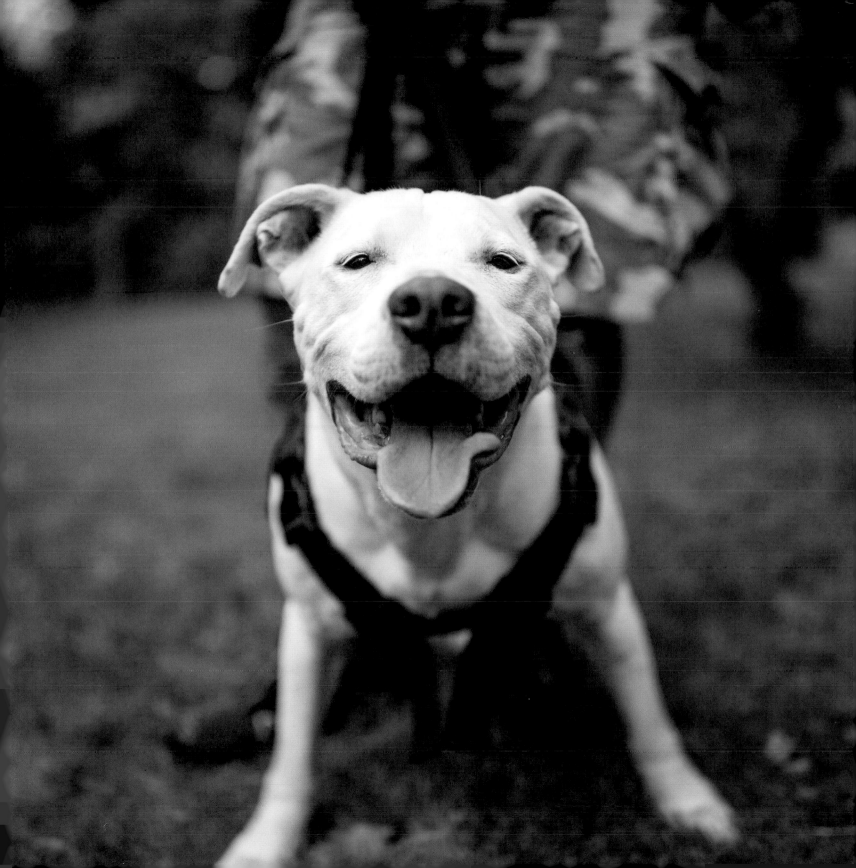

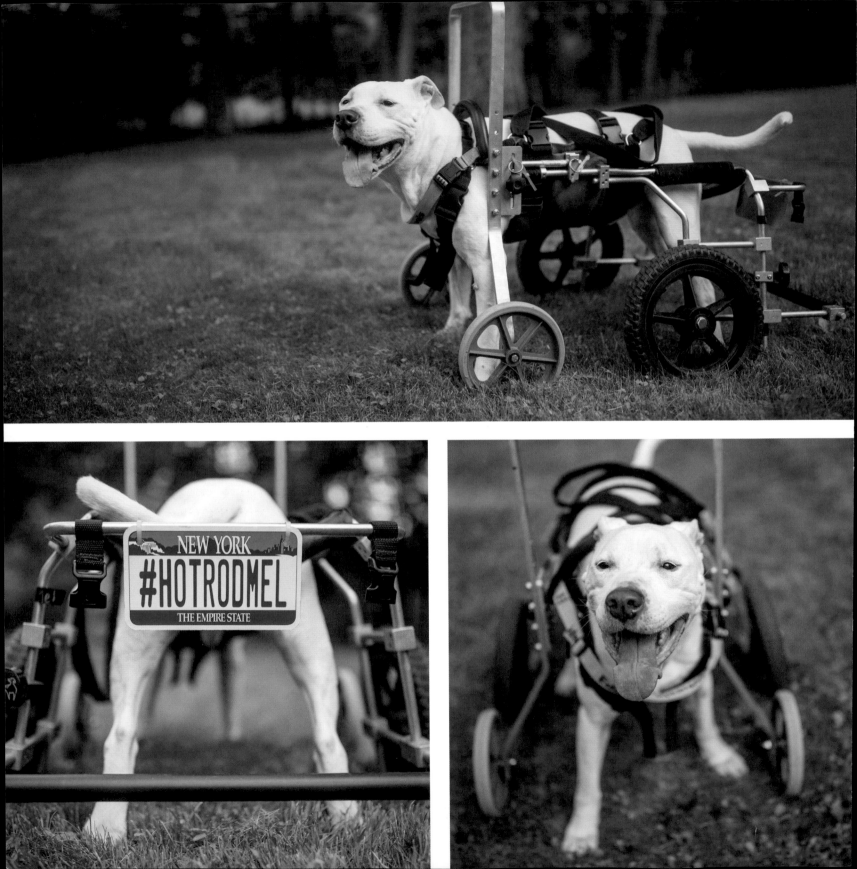

so they, and Mel, drove up for a visit. When they arrived at the factory, the employees observed how Mel walked and took his measurements to determine what type of wheels he needed. Within two weeks, Mel's wheelchair was ready, and the three of them made the drive back up to Massachusetts to test it out. After some minor adjustments, Mel was off and running. He immediately ran all the way back to the car!

There wasn't much of a learning curve for Mel. He knew how to use his new wheels right away and enjoyed his newfound mobility. Whenever Mel hears the wheels come out, he gets excited and knows that they're about to go for a walk, hike, or car ride.

Mel enjoys traveling and loves being in the car. He's been all over the United States and has lived in Florida, Colorado, and New York. Tom and Tamara always set him up in the car first when preparing for a journey, because Mel likes to know that he is coming along with them. Terrain doesn't seem to matter when they are traveling or exploring the trails near their home;

Mel can wheel over rock, through mud, and on damp beach sand. Sometimes he even gets wet while running through the ocean shoreline.

Mel has changed the lives of Tom and Tamara for the better. Taking care of him requires a lot of work, but they have never thought for a moment to do anything less than make Mel's life the best it can be. Because of his mobility issues, if he's not in his crate or on his bed, they have to monitor his every move. Mel still attempts to walk on his own and can get up on four legs at times. However, it can be dangerous if he tries to move once he's standing. They are always nearby to make sure Mel is safe. Sometimes he gets frustrated when he wants to get up and is unable to move. When this happens, Mel lets out a distinct whine that lets his parents know he's thirsty or wants to go outside.

Mel helps to change other's perceptions about bully breeds with his sweet demeanor and resilient attitude. He is a great ambassador for pit bulls and Tom and Tamara would not trade him for the world.

ELVIS

Elvis was taken to Orange County Animal Care in 2013 as a stray and labeled by the staff as "dog and people aggressive." A Priceless Pet Rescue volunteer saw Elvis on a social media post promoting his adoption and shared him on a message board with other volunteers. Elvis was scheduled to be euthanized the next day and could only be adopted out to a rescue organization that was willing to rehabilitate him before adopting him out to a forever home. Everyone wanted Elvis out of the pound, but only one person was available to foster him at that time. John arrived at the shelter just hours before Elvis's euthanization was scheduled to occur. He took Elvis in as a medical foster and the plan was to put Elvis up for adoption once he was healthy.

John was very excited to work with Elvis since he was his first foster. It became quickly evident that Elvis was mislabeled as "aggressive." He didn't have any issues in John's care and was likely acting out in the shelter because he was living in a kennel surrounded by unfamiliar dogs and humans. John, a dog trainer, witnessed how well-behaved Elvis was in every situation. He didn't even have to train him! After fostering Elvis for four weeks, John decided that he couldn't let him go and adopted Elvis himself.

In 2014 John created a blog titled *I Pitty the Bull*, about his journey through life with Elvis, his other dogs, and the dogs that he fostered. Inspired by Elvis, the blog was an outlet that helped John cope as he dealt with some serious health issues. Today, it is a

nonprofit organization based on humane education and was the first organization to adopt the Lucky Dog Humane Education curriculum, which seeks to inspire children to feel compassion for people, animals, and all living creatures.

Elvis is the face of I Pitty the Bull. He's on just about every shirt, logo, and sticker, and he's John's right-hand man at almost every speaking event and humane education class that John does with children. John has a fear of public speaking that disappears when Elvis is by his side. Elvis goes to schools with John to help teach kids about being kind to animals and how to safely and properly approach dogs. The children practice what they've learned on Elvis. I Pitty the Bull also discusses breed discrimination with the children and relates it to bullying in the schools as part of the organization's anti-bullying campaign.

John and Elvis are also involved with the Pawsitive Change Prison Program. Pawsitive Change matches death row dogs (dogs on track to be euthanized) with inmates inside California state prisons. The program's goal is to reduce inmate recidivism by providing them a real-world skill, while at the same time, saving a dog's life. The inmates work toward vocational accreditation and the dogs work toward their Canine Good Citizen certification. The inmate and the dog use the skills gained in this program to better their lives and stay out of prisons and shelters. John visits a maximum security prison once a week as part of the program. At the beginning of his involvement, Elvis would often attend. However, John wanted to bring in more difficult dogs who needed more training; Elvis eventually stopped visiting the jails because he is so well behaved and well trained. Nice job, Elvis!

According to John, Elvis is one of those dogs that makes people want a pit bull–type dog. He performs well in all types of situations and everyone falls in love with him. John describes Elvis as everyone's best friend and a great teacher's assistant. While Elvis is known for lacking facial expression and often looking unimpressed, he is full of love. Some of his favorite activities include going to the beach, chasing tennis balls, playing with other dogs, and getting attention from humans. Because of Elvis, John has fostered about one hundred rescues over the past six years. He takes in all types, from medical cases to behavior cases and everything in between.

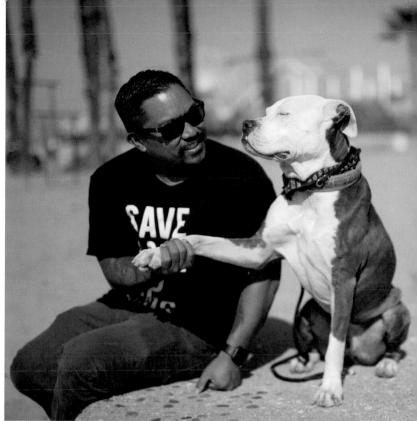
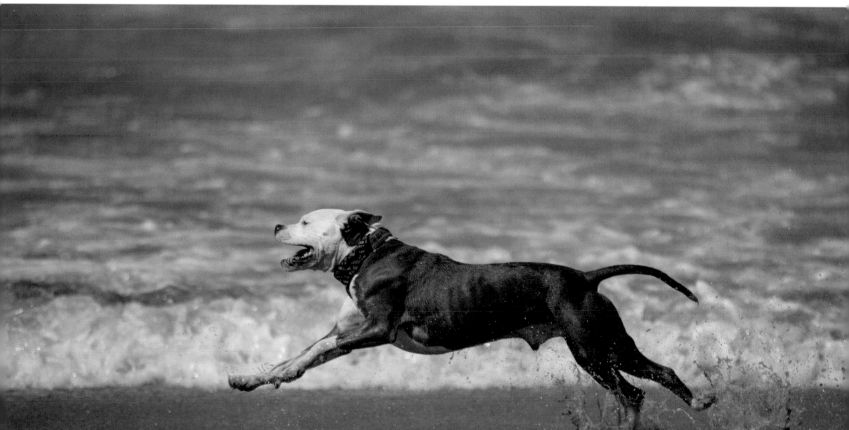

ROXY

Dina was never fond of dogs. Kayla, her daughter, has loved dogs from the time she was very young. She fell in love with her older brother's boxer/pit bull mix named Liberty, and Kayla's disappointment was palpable every time they had to part ways.

Outside of family and work, Kayla didn't have any friends and didn't have many opportunities to socialize with others. Kayla has Down syndrome, which limits her ability to communicate easily. Despite Dina's lack of enthusiasm for dogs, she thought having one might help Kayla open up, build her self-confidence, and give her some companionship.

When Dina saw Roxy's picture posted on social media by a local rescue, she was blown away. Roxy looked *exactly* like Liberty did as a puppy. Dina had hoped to find a rescue dog who was similar to Liberty because of how much Roxy adored her. They adopted Roxy, a pit bull mix, the very next day.

Before Roxy came into their lives, Dina struggled to get Kayla to leave the house. Now Roxy gives Kayla a reason to get out and do things, such as going for walks and playing outside. These activities are crucial for Kayla since, due to her Down syndrome, she is prone to being overweight.

Kayla did not require much prompting to start training Roxy. She jumped right in and began interacting with her right away. The more of a response Kayla got, the more inspired she was to continue with training. With training came communication.

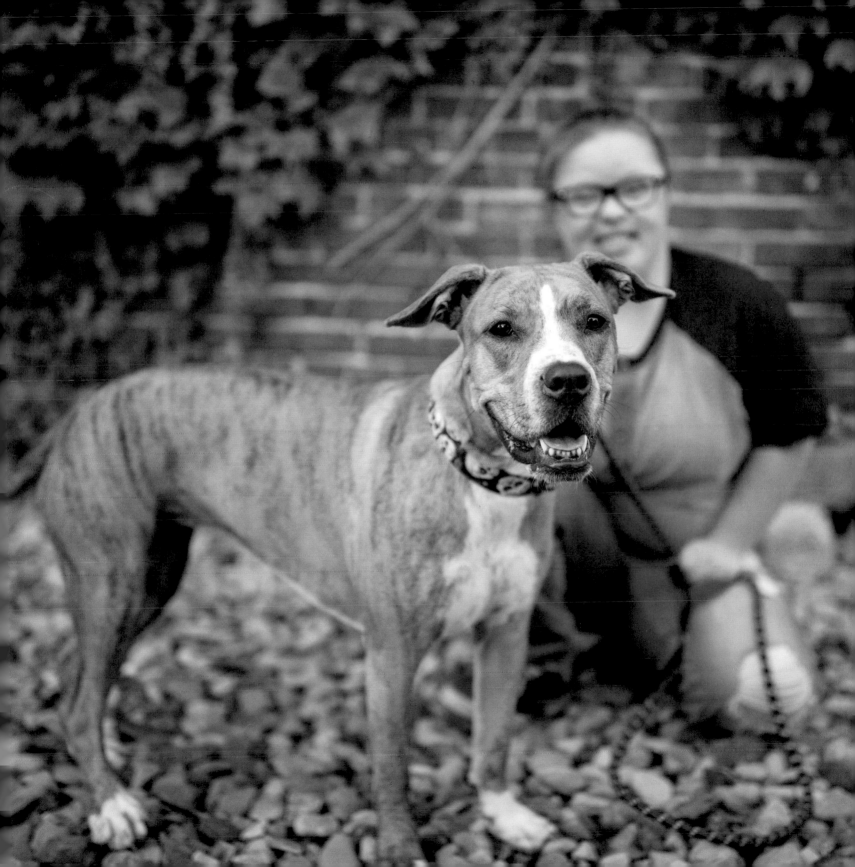

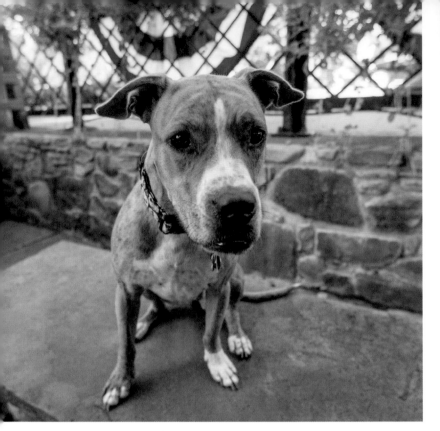

"Roxy and Kayla have a symbiotic connection—they grow and learn from each other every day."

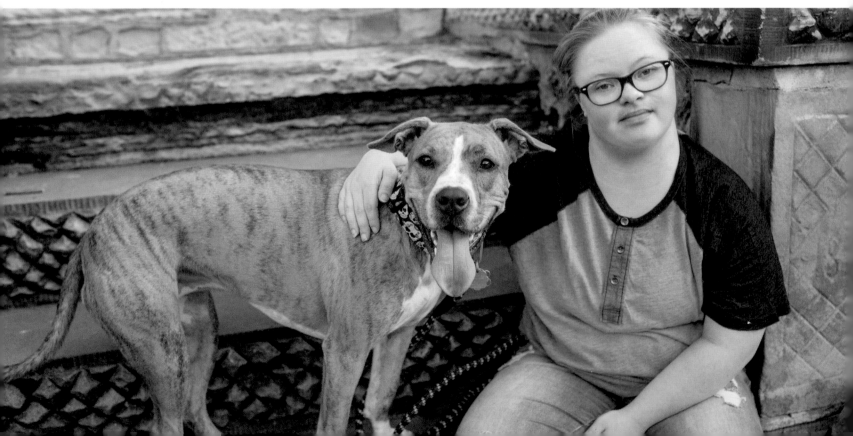

ROXY

Kayla has become significantly more verbal since taking on the role of teacher. Roxy puts up with Kayla's high-performance standards and they even show off their tricks to complete strangers while on walks.

Speech is by far the most significant challenge that Kayla faces in her everyday life. Receptively, Kayla understands about 85 percent of what people tell her. Expressively, Kayla is only able to communicate about 20 percent of her thoughts into words. Roxy always responds to Kayla when Kayla gives her a command. The positive responses from Roxy encourage Kayla to talk more, and Dina has observed Kayla's vocabulary grow in the time that she and Roxy have been together.

Roxy and Kayla have a symbiotic connection—they grow and learn from each other every day. Roxy brings out a sense of acceptance, importance, and necessity in Kayla. Kayla understands that Roxy loves and needs her, and misses her when they are apart. Kayla has never experienced this before. She uses their time together to play, train, and bond with Roxy.

Dina loves Roxy for what she brings to their family. Roxy has caused their home to become the center gathering place once again. It's something the family had drifted away from when their lives became so busy and everyone went in different directions. Dina says Roxy has centered them once again. There is something especially therapeutic about sitting next to Roxy on the couch at night with the family all together. Roxy is such a positive spirit.

Kayla and Roxy also enjoy playing fetch, watching movies, snuggling on the couch, and going on car rides together. Roxy loves playing with basketballs, tennis balls, and anything that's full of fluff and squeakers. Subscription toy and treat box delivery day is like Christmas for both Roxy and Kayla. Each box provides Kayla with two bags of treats which she uses to reward Roxy during training sessions.

Kayla and Roxy have a bond that strengthens every day. They have a mutual adoration and respect for each other that can't be taught. They both know, intuitively, that they need each other for all to be well with their worlds.

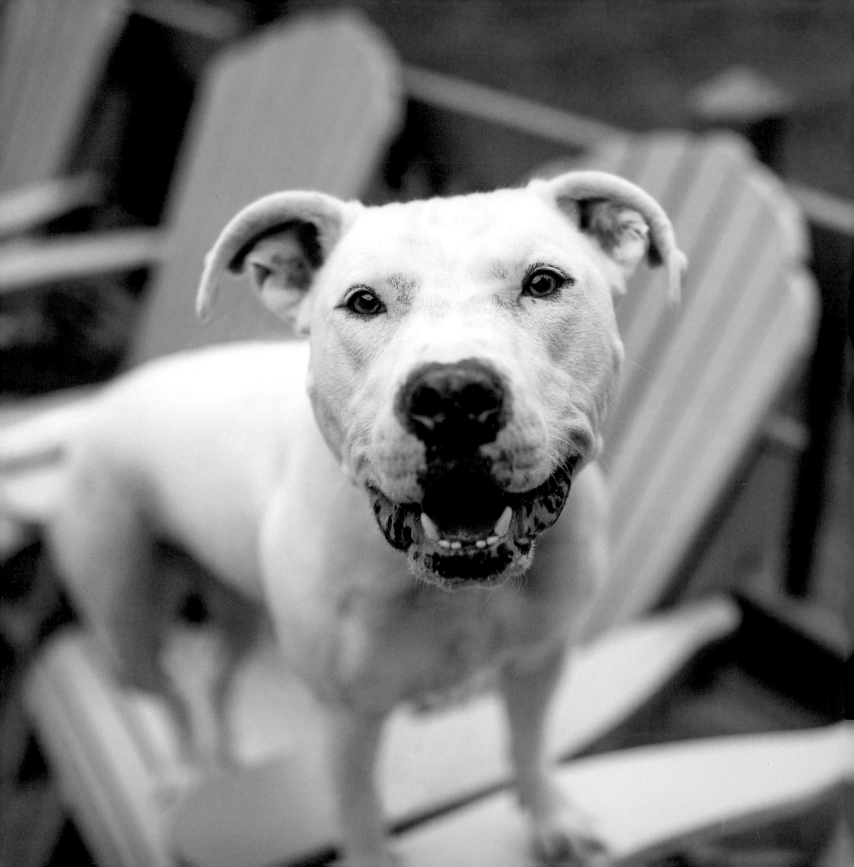

ACORN

Mary, a college professor in Cleveland, was volunteering as a dog walker at the Cleveland Kennel in 2016 when the kennel manager asked her to take a puppy home for the weekend. The puppy was Acorn; he was only a couple months old and had been picked up as a stray on Halloween after playfully tagging along with trick-or-treating children. Acorn would amuse himself with his water bowl by banging it against the sides of his kennel all day, every day. This noise drove the other dogs, staff, and volunteers crazy, though everyone assumed he was just stressed and bored. A change of scenery would do him good.

When Mary brought Acorn home that day, he went wild. He jumped on furniture, knocked chairs and lamps over, and ran in circles through her house. Unlike many dogs, Acorn wouldn't react when Mary raised her voice at him; he wouldn't listen to a word she said. He finally wore himself out, giving Mary the opportunity to put him in his crate for the night.

Mary recognized that she couldn't handle Acorn's extreme behavior and so decided to take him back to the kennel. The next morning, when she opened the door to Acorn's room, he didn't move an inch. Mary knocked on the door hard, to see if he'd react, and even blew a whistle. Nothing would wake him. She touched him gently when she opened the crate and that's when he woke up and smiled at her. It was at that moment that Mary knew Acorn was deaf.

She immediately reached out to Trish McMillan, a friend and well-known animal behavioralist (see "Theodore" on page 57). When Mary told Trish she had brought home a deaf puppy, Trish responded unruffled, "So what? Teach him sign language and start with 'watch me.'"

ACORN

Mary began to research deaf dogs and reached out to others with experience. A couple different people suggested she teach Acorn British or American Sign Language. Mary didn't know either and didn't have time to waste, so she made up her own signals, beginning with "watch me." By the time the weekend was over, Acorn knew the sign for "sit," "down," "shake right," "shake left," and "watch me."

The kennel had planned to transfer Acorn to another rescue organization but Mary wanted to foster him, making Acorn the first deaf dog accepted into the city kennel's foster program. In the months that followed, Acorn's vocabulary grew, and Mary decided it was time to enroll him in a basic obedience class. He excelled, finishing at the top of his class even though he was the youngest and the only deaf dog there. They enrolled in Obedience II, and again, Acorn outshined the other dogs. It was clear to Mary that Acorn was smart; being deaf would not limit him in any way.

For ten months, Mary and the kennel attempted to find Acorn his forever home, without success. Many people are afraid of adopting a deaf dog and the stigma of being a pit bull didn't help. In September 2017, Mary realized Acorn already had his forever home—with her!—and decided to adopt him. They were a team, and Acorn was going to make an outstanding ambassador for deaf dogs.

The day that Mary officially adopted Acorn, she was asked to submit his story to the Petco Foundation's Holiday Wishes Grant Campaign. In five hundred words, Mary shared the story of how Acorn changed her life. Acorn and Mary were one of fifty-two winners out of about ten thousand submissions, and the foundation granted ten thousand dollars to the Cleveland Kennel on behalf of Mary and Acorn.

Acorn loves people of all ages. He is still learning to control his excitement when he first meets someone but settles down quickly once Mary starts signing to him. Mary consistently uses sixteen different signs with Acorn! He loves hiking, camping, and backpacking with Mary. Whether it is a creek, pond, or the bathtub, Acorn relishes being in the water.

As an advocate for pit bull–type dogs and volunteer with the Cleveland Kennel, Mary's work doesn't stop with Acorn. She continues to walk dogs, serves as an adoption counselor, and attends community events. The nonprofit arm of the kennel, Friends of the Cleveland Kennel, takes adoptable dogs to more than 250 events each year in and around the Cleveland area.

Today, few people know that Acorn is deaf because he acts like any other dog. When he does what Mary tells him, she talks to him even though he can't hear her. People view him as a well-trained dog, doing what she tells him; the people he meets are not watching Mary's hands, but Acorn always is.

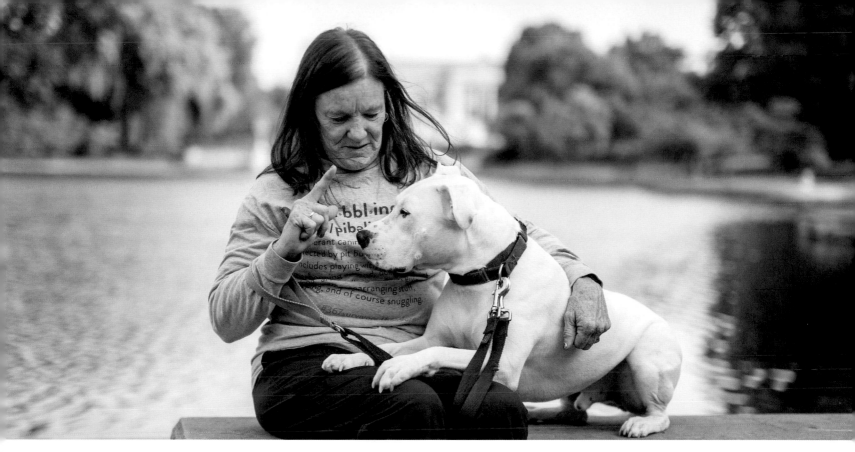

CALISTA

A dog was found as a stray on the streets of Phoenix, Arizona, by a police officer in 2013. She was extremely dirty, leading her rescuers to think she was brown. Her ears were so severely injured by another dog (or dogs) that they were unable to be saved. She was covered in ticks, emaciated, and lucky to be alive. It is still unknown what terrible circumstances caused her injuries.

She was taken to a shelter which contacted one of their partner rescue organizations which specialized in extreme medical cases. The rescue contacted Jeannette and John that day to see if they would foster the dog until she was healthy enough to be adopted. The two had recently lost their first dog, Bambina, and had another rescue pit bull mix at the time named Zazu. Bambina, a pit bull mix and inspiration behind Jeannette and John's advocacy, had one eye and poorly cropped ears. Zazu was at her side until her passing, and they could see how depressed he was after she left.

The organization didn't send photos to Jeanette and John, but did email them a synopsis saying the rescued dog may be blind or have significant trouble seeing. There wasn't a moment of hesitation for the two. They read the email aloud in bed and instantly decided to take her in as a foster. A few members of the rescue along with John picked her up and took her to an emergency veterinarian where Jeannette was waiting. Not knowing if the dog would survive her first night in the hospital, they named her Calista. They wanted to make sure that if she passed on, she had a

CALISTA

name. Calista means "most beautiful" in Greek. Physically, Calista was in terrible shape; the worst that many had ever seen. Inside, she was resilient and courageous. She was beautiful in the eyes of Jeannette and John.

After surviving the night and multiple reconstructive surgeries, Calista was able to go to her foster home a week after being rescued. When Zazu first met Calista, he could tell that she was not well, and Jeannette believes he knew that he had a purpose. Calista was terrified and had every reason to be. She was fearful around people, afraid of food, and even became nervous around jingling keys. She overcame all of her fears pretty quickly thanks to the bond developed with John, Jeannette, and Zazu. The three have been with her since the beginning of her new life.

Calista was fostered for about two months when the rescue organization determined she was both physically and mentally healthy enough to be adopted. It was an easy decision for Jeannette, John, and Zazu to make Calista a permanent member of their family.

Calista loves meeting new people; it's one of her favorite things to do. Jeannette calls her a "social butterfly." They have attended outdoor events where Calista has insisted Jeannette walk toward the crowds to meet people. If she notices a person that is upset, Calista will approach them to provide comfort.

Calista is known for her constantly wagging tail, which often creates a steady drumbeat on the wood floors of their home. Jeannette and John refer to her as their "little tail drummer." If she's not drumming, she's often licking people's legs when they come over to visit.

Calista is now known to hundreds of thousands of people around the world. Jeannette started her social media accounts so that people could follow along as she recovered. Jeannette wanted Calista's followers to see how far their donations went. She wanted them to know that it wasn't just about donating for medical procedures; it was about the amazing life Calista was now living because of their generosity. Most people follow Calista because she makes them happy. Jeannette knows this because she gets multiple messages and emails every day from followers.

Her social media pages are also used to advocate for pit bull–type dogs. Jeannette and John have created an open dialogue to discuss the stigma and issues surrounding them. They even welcome people who are fearful of pit bull–type dogs and encourage them to share their feelings and experiences. Jeannette and John focus on ways to educate others and offer advice on how to manage uncomfortable questions about pit bulls. This open dialogue has lead many to foster and adopt a pit bull for the first time. Others have told Jeannette and John that they no longer fear pit bull–type dogs because of Calista.

BUFORD

Buford was found roaming the streets of suburban Chicago in late 2014. After repeated efforts by animal control to contact his owners (they never came to pick him up), he was sent to an animal shelter in the area. Five months into his time there, he began to shut down. All of that time in a kennel was becoming mentally difficult for Buford. That's when the shelter decided to reach out to Pits for Patriots for assistance.

Pits for Patriots is a Chicagoland-based registered 501(c)3 nonprofit. Founded in May of 2011, Pits for Patriots trains qualified pit bull–type dogs from various Chicago-area dog rescues and shelters to work as service, therapy, skilled companion, or companion dogs for US military veterans and first responders such as police, fire, and emergency medical service personnel.

When volunteers from Pits for Patriots came to meet Buford at the shelter, they knew immediately that he'd be a good fit for their program; the shelter often takes dogs to the nursing home across the street to provide companionship for the residents, and Buford was a participant in that program while at the kennel—they even had photos to share of Buford doing this therapy work.

Thanks to donations, Pits for Patriots was able to treat Buford's many medical issues, which included an untreated pelvic fracture and a torn ACL. Unfortunately, because of physical limitations related to the surgeries, Buford could not be trained as

a service dog to a veteran or first responder. Pits for Patriots did, however, believe that he'd make a great therapy dog.

Soon a firefighter and Pits for Patriots volunteer named Joe met Buford. There was an immediate connection between the two—Buford wouldn't leave Joe's side—so Joe and his wife adopted him. Buford now has the forever home he deserves and has become the official mascot and companion at Joe's firehouse in suburban Chicago. Buford sometimes visits the firehouse while Joe is working but due to an inability to walk up the stairs because of his medical issues, he is unable to visit as much as originally hoped.

However, his physical limitations didn't hold Buford back from playing an important role in others' lives. After six months of obedience training, Buford passed his certifications and became a registered therapy dog. Joe and Buford can be found helping out children through the Paws for Strength program at Hephzibah Home

in Oak Park, Illinois. The Hephzibah Home offers short- and long-term group homes for children traumatized by neglect and abuse. Paws for Strength, founded and supported by the Bryan and Amanda Bickell Foundation, helps these children by connecting them with certified therapy pit bull–type dogs. When they visit the kids, Joe first teaches them about dogs, their behavior, how to approach them, and some basic commands prior to them spending time with Buford. The children always look forwarding to their time with Buford, and Buford loves to see them and make a positive difference in their lives.

Buford is loyal, sweet, goofy, loving, and enjoys lazy days on the couch or sunbathing in the driveway. When someone is having a bad day, he cuddles up next to them. A true therapy dog, Buford cares about everyone around him and enjoys making a positive impact on the lives of others.

"Buford now has the forever home he deserves and has become the official mascot and companion at Joe's firehouse in suburban Chicago."

CHANGO

In the fall of 2008, a two-month-old puppy named Chango Leon was given as a gift to a young child. Shortly after bringing Chango into their home, the child's father became worried about how large Chango would get and realized it would be best to surrender the dog to a shelter. On the way to the shelter, the family stopped, fortuitously, at a repair shop to get some needed work done on their car.

The mechanic noticed Chango in the back of the car and struck up a conversation with the family about dogs. When he learned Chango was about to be surrendered to a pound, he called his girlfriend, Evelyn. They couldn't imagine this friendly little puppy being left at the pound and quickly decided to give Chango a forever home.

As Chango grew, Evelyn noticed something happening during their walks together: People were conspicuously crossing the street to avoid being near him. She even heard some parents tell their children to "stay away because that dog bites." This upset Evelyn; Chango had never hurt anyone and had never done anything to warrant that kind of reaction from people. They were avoiding Chango because of their misconceptions about pit bull–type dogs, and Evelyn was not OK with that.

So what did Evelyn do to make Chango look less intimidating? She dressed him up in a hoodie and took him on a walk. Evelyn noticed an immediate difference in the way people reacted to him. Strangers avoided Chango less and were more likely to want to approach him to say hello.

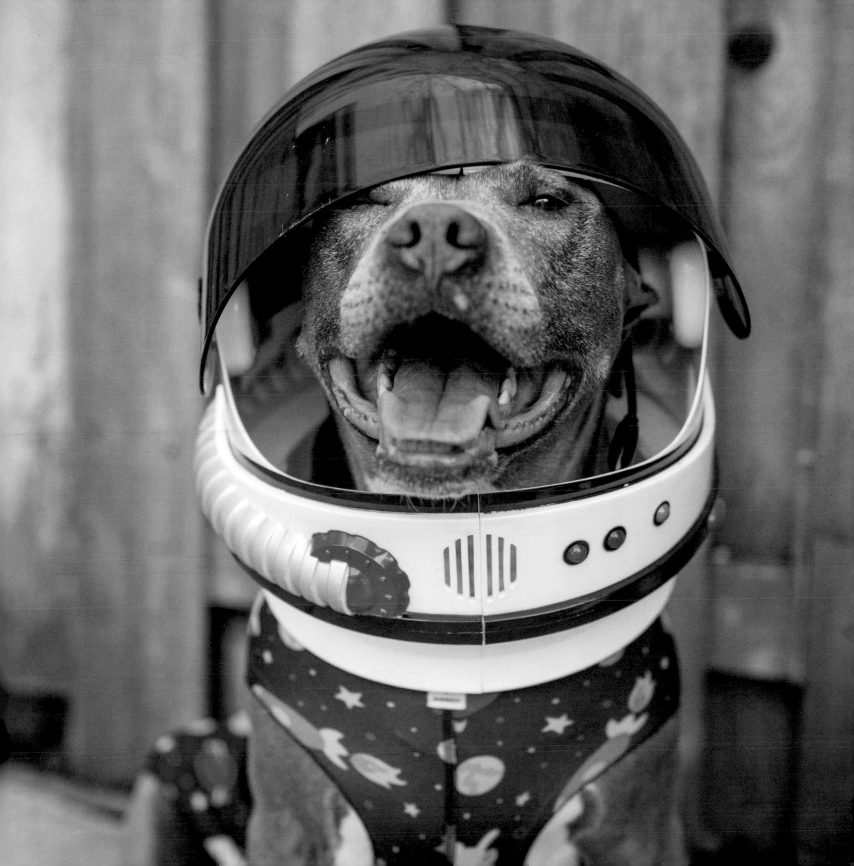

"Chango has been dressed in well over one hundred different outfits and costumes since Evelyn first put that hoodie on him."

CHANGO

After dressing Chango up in a few different outfits, Evelyn began taking photos of him in each one and posted them on his newly created Instagram account. The account quickly gained thousands of followers and led to interview requests from around the country.

His mellow nature makes Chango a good dog for dressing up. He has never had an issue with the outfits which often include eyeglasses, wigs, and helmets. Chango has been dressed in well over one hundred different outfits and costumes since Evelyn first put that hoodie on him. The costumes include Superman; a bunny rabbit; a hamburger; an astronaut; a minion; Chicago Cubs, Bears, and Bulls players; an elf; and more. Given that Chango enjoys napping and cuddling so much, his pajamas are his favorite outfit to wear.

Not only has Chango helped others to view pit bulls in a more positive light, he has also raised money for dogs in need. In 2015, Evelyn posted photos of Chango on Dogly, a photo-sharing website for dog lovers. The photos of him dressed up in his outfits were so popular that he received a five hundred dollar grant from Dogly for Chicagoland Bully Breed Rescue (CBBR).

When he's not dressing up, Chango can often be found spending time with his best friend, Evelyn's two-year-old niece, Andrea. They met each other for the first time when Andrea was about five months old. Never having met a baby before, Chango was very curious at first, sniffing her from head to toe. They can often be found playing with toys, dressing up, and eating snacks together. Andrea especially enjoys giving Chango massages on his rear end.

Chango's other favorite activities include chasing squirrels, visiting the beach, rolling around in the grass, spending time with Evelyn's mom, walking with his stick, basking in the sun, and leaning his head out the window so he can smell the world.

THEODORE

On August 23, 2013, 367 dogs were rescued as part of the US's second-largest dogfighting raid. The initial raid turned up new information, and the final number of dogs rescued as a result was 486 in four states: Alabama, Georgia, Mississippi, and Texas. The raid culminated after a three-year investigation by the FBI and local authorities.

Trish McMillan, a certified professional dog trainer and dog behavior consultant, was called in by the ASPCA in September 2013 to assist with the rescued dogs. Trish does behavior consulting work for dogs, cats, and horses, and teaches nationally and internationally on animal behavior topics. Trish is most sought after for her talks on aggression in dogs and shelter behavior. For about ten days a month, from September through April 2014, Trish was a behavior lead while the dogs were being held as evidence for the court cases related to the fighting ring. During this time, she assessed and trained the dogs to prepare them for adoption.

Felix was eight months old when he was seized in the raid. Because of his young age, he had never been fought. He had no behavior problems and wasn't being focused on by the behavioral team.

They nicknamed Felix the Golden Boy because he could play nicely with any dog. Even though he grew up attached to a chain and spent eight months in a cage with no dog-to-dog contact, Felix was exceptional at getting along with all types of dogs. He could roughhouse with the rowdiest of the dogs; he could turn into a small and

peaceful dog to bring the shy ones out of their shells. If a dog began to act aggressively, Felix knew how to defuse the situation. With skills like that, he was a dog trainer's dream. Trish immediately saw how special he was.

After his owner was sent to jail, Felix was free to leave the shelter. As Trish prepared Felix to be transferred to the Bully Project in New York City, her heart sank. "That's my dog, and he's heading to someone else," she thought to herself.

Less than a week after Felix made it to New York City, Trish made arrangements to pick him up. She was adopting him! He was to be named Theodore, which means "God's Gift" in Greek. Theo's new home with Trish would be on a farm near Asheville, North Carolina.

Theo does well with all the animals on the farm. Horses, goats, cats . . . he loves them all! He can often be found trying to play with the goats. Unfortunately for Theo, their answer is always no. And of course, he is an excellent companion for Trish's other two dogs, Aleli and Maggie. Maggie, a Doberman pinscher, is Theo's favorite playmate. They spend their days chasing and wrestling each other. Theo is Trish's chief assistant when it comes to her dog training business. He often helps out with fearful dogs by teaching them to be confident with new situations and people. Theo doesn't negatively react to dogs who lunge and bark while on a leash, so he is often the first dog that Trish will walk reactive dogs past during training. When Trish does client visits, Theo often comes along in case he is needed. After he helps their dogs, Trish loves telling clients that her little pit bull came from a dogfighting bust.

When Theo is happy, he gives kisses and hugs or wildly rolls around on his back. If he's bored, he makes "art," piling up random objects on his dog bed, such as a toilet brush, magazines, and bottles from the recycling bin. Trish coined the term "pibbling" to describe all the silly things bully breed dogs do every day, and even managed to get it into the Urban Dictionary.

Theo spent his puppyhood on a chain and much of his youth in a shelter cage. Like so many rescued dogs, even though he came from a difficult background, he's still an incredible, loving dog who adores all people and all animals.

TACO

Just like Theodore, Taco's new life began on August 23, 2013. He was also one of the 367 dogs rescued in the infamous dogfighting ring bust. Taco, less than a year old at the time, was rescued on a property with dozens of other dogs who were restrained by heavy chains and had only 55-gallon blue barrels for "shelter." Like many of the other dogs, he was underweight and terrified.

While the criminal cases worked their way through the court system, Taco was held at the Humane Society of the United States' (HSUS) temporary shelter with the other survivors. He was named Taco by Heather Gutshall (human to Handsome Dan, a Michael Vick survivor, and Tillie, another "367" survivor). Heather was volunteering her time for HSUS at the temporary shelter with twelve other people from the organization she founded, Handsome Dan's Rescue. She named him Taco because he was so serious and fearful; Heather thought a fun name would help people view him in a more positive light.

On February 23, 2014, two Bark Nation board members, Kelly and Erin, set out on a journey to transport three of the most fearful "367" survivors from Alabama to Michigan where they would be prepared for adoption. Bark Nation, a nonprofit based out of the Detroit area, is a canine advocacy, intervention, and shelter organization which was just starting out at the time. The three dogs transported were Taco, Zander, and Homer. Kelly and Erin spent weeks volunteering at the HSUS shelter

"Because of his stroller, Taco is now able to explore the world around him at his own pace."

TACO

in Alabama, reading to the dogs and singing to them while working to calm their fearful trembling. Unfortunately, their fearfulness did not make any of the three dogs strong candidates for placement into a forever home. After returning to Michigan, Taco and Zander found their forever home with Kelly.

Taco has improved immensely since August 2013. When Kelly first met him, it took an hour before he would accept a treat from a stranger's hand. Today, Taco will take a treat instantly from anyone!

Taco acted like a normal dog in his backyard, but his fear prevented him from venturing outside his home. He would "pancake" almost immediately when his humans attempted to walk him on a leash, so they tried a stroller instead—and he loved it! The stroller is his safe space and no one is allowed to approach him when he is in it. While he is still fearful at times, Taco is a much different dog since his rescue from the dogfighting ring. Because of his stroller, Taco is now able to explore the world around him at his own pace.

Taco continues to play an important role at Bark Nation. He was one of the three original dogs accepted into their shelter and has become a beloved social media personality. His wonky ear, awkward teeth, and sassy demeanor have made him a recognizable face to many who follow the organization online. He helps Bark Nation share survivor stories with a bit of humor and brings a much-needed lightheartedness to the heavy issues the animal welfare community deals with on a daily basis. According to Kelly, Taco's online persona is "deliciously naughty," calling people "turds" and "poop faces" as a way to grab their attention and get them to volunteer or donate.

Taco has made Kelly a better advocate by inspiring her to expand her dog behavior knowledge, especially when it comes to rehabilitating and training fearful dogs. His floppy ear and social media "voice" now brings smiles to thousands in the animal welfare community who need to have a good laugh and see a happy ending.

GEMMA

LOS ANGELES

It's not often that you get to watch a little boy and his dog grow up together on social media—but thousands around the world have been doing that with Gemma and Elliot since 2013.

Two years before Elliot was born, his mother, Brianna, rescued Gemma. Brianna had originally planned on rescuing a senior pit bull–type dog. She had fallen in love with them at the veterinary clinic where she worked and became attached to their warm, sweet nature. But instead of rescuing a senior dog, Brianna and her family found themselves rescuing Gemma the puppy pit bull, who turned out to be perfect for their family.

Elliot was born in 2013 and Gemma has been by his side since day one. From the moment Elliot came home from the hospital, Gemma stayed close by. She watched him sleep and was constantly smelling and kissing Elliot. Gemma has been his protector ever since. As a baby, when Elliot got too close to the stairs, Gemma would block him from climbing them to keep him safe. She treated him as one of her own.

Brianna was so endeared by their bond, she decided to create an Instagram account to document their friendship. A video of Gemma kissing baby Elliott went viral and their account quickly became very popular.

Elliot loves receiving kisses from Gemma and even shares his peanut butter with her. He gives Gemma baths, cuddles with her, feeds her, sings and reads to her, and the two often watch movies together.

GEMMA

Gemma became so attached to Elliot that when he began leaving the house to attend school, she became visibly sad and lonely. Brianna decided to adopt a cat named Boops to give her company. The dog and cat quickly became friends and Gemma was noticeably happier. The two can often be found cuddling together or giving the other a tongue bath.

Because of the negative stereotype that some people have of pit bulls, Brianna is sometimes on the receiving end of negative comments. Luckily, the hate pales in comparison to the positive responses that are sent their way. Brianna does her best to educate people as much as she can.

As frustrating as the negativity can be at times, getting angry gets her nowhere. Brianna always tries to be the best advocate for pit bulls she can be. She focuses on the importance of education and avoids the hostile comments.

Gemma has taught Brianna what unconditional love is through her affection for Elliott and Boops the cat. Gemma's gentle nature brings happiness to all of those around her. Gemma is beautiful, patient, sweet, and nurturing. She loves Brianna's family unconditionally and has taught her children what responsibility, friendship, compassion, and empathy are.

DOBBY

Dobby was found by a police officer in Cleveland, Ohio, on December 24, 2014 after a call about a stray puppy. The dispatcher at the police station who handled the call felt that the stray dog would be an excellent fit for Secondhand Mutts, a rescue and adoption center where she volunteered. The dispatcher took him home that evening and dropped him off at the rescue the following day.

Fifteen-year-old Lara and her mother, Julie, had started volunteering at Secondhand Mutts just a few months earlier. They walked dogs and helped at off-site adoption events held at local pet supply stores. Lara began volunteering to fulfill her high school's sophomore service requirements. After her first walk with one of the dogs up for adoption, Lara knew that she wanted to continue volunteering even after her service requirement was complete. She loved being able to spend time with the adoptable dogs as it helped to improve not only the dogs' happiness but also hers.

Lara saw Dobby on the Secondhand Mutts website the first week of January 2015. When she and Julie found out that he would be at an adoption event, they went to meet him in person. The two fell for his sweet personality, unlimited kisses to everyone he met, green eyes, and huge ears. Lara filled out the adoption paperwork that day.

After the adoption event, Lara and Julie went to Secondhand Mutts every day to volunteer and walk Dobby. Several people had put in applications to adopt him, but Lara and her mother had an advantage because they volunteered for the organization

"Once Dobby's gentle personality is revealed, any negative judgment turns into a positive experience."

DOBBY

and were spending their days getting to know him. A couple weeks after the event, Dobby was officially adopted and given a forever home with Lara and her family.

Lara, like many high schoolers, had her fair share of stressful times. Dobby was always there to cheer her up during the challenging moments. He greeted Lara at the door, cuddled with her on the couch, and snuggled with her in bed. For Lara, Dobby was a best friend that helped relieve her stress and anxiety when she needed it the most. Life was better with him in it, and Lara was grateful for his presence every day during that time.

Lara has become an advocate for pit bull–type dogs because of Dobby. He was the inspiration behind her college essay which educated people on pit bulls and the many misconceptions about them.

Dobby has changed the minds of many who viewed him as dangerous based solely on his looks. When Lara's neighbor found out Dobby was a pit bull, he was hesitant to approach him at first. One treat and a few kisses later, her neighbor became a Dobby fan. It's not uncommon for people's initial reaction to be nervousness when they see him. But once Dobby's gentle personality is revealed, any negative judgment turns into a positive experience.

Dobby enjoys walks in the park, visiting the pet supply store, spending time with the cats, and playing with his four dog siblings. He especially enjoys going for car rides so he can hang his head out the window and let his large ears flap in the wind. If there is a dog-friendly restaurant patio in the area, it's likely that Dobby has been there. On sunny days, he'll spend hours in the driveway basking in the sun. His favorite activity is watching TV with Lara on the couch.

Dobby is a father figure to the four other dogs and two cats in the house. He is the gentle giant of the family who keeps everyone relaxed and happy. Dobby gathers all of the dogs up for nap time a couple times a day and loves being the leader of play time in the backyard. He even occasionally bathes the cats with his tongue.

Even though Lara and her family weren't looking for another dog when Dobby came into their lives, it was perfect timing for everyone. Dobby has a special relationship with Lara and the rest of her family. His presence brought joy to the household and turned the whole family into advocates for blocky-headed pit bull–type dogs.

TYRION

Tyrion was found in a Georgia dogfighting ring in 2014 by the Humane Society of the United States. Not only did he lack a necessary amount of food and water, but he also spent his days in the hot sun with minimal shade before he and the other dogs on the property were rescued. Hello Bully, an organization in Pittsburgh that advocates for, rescues, and rehabilitates pit bull–type dogs, offered to take him under their care for rehabilitation and future adoption.

Tyrion's muzzle was severely injured and required multiple operations to help with his respiratory issues. Thousands of dollars were raised by Hello Bully to cover his medical costs. The money raised included a grant from the Ian Somerhalder Foundation, the foundation's first-ever grant to help an animal.

At about this same time, a thirteen-year-old pit bull mix named Buster passed away. His parents, Laurie and Bernie, decided that they didn't want to go through the heartbreak of losing a dog again and believed it would be best for them to foster dogs instead.

When Laurie and her daughter went to visit the staff at Hello Bully to inquire about fostering, they were introduced to Tyrion. He melted Laurie's heart the second she laid eyes on him. He looked different than all the other dogs and Laurie fell for him and his forgiving spirit.

Tyrion was very nervous when out in public and also limped on one of his legs. He would only walk about one hundred feet at a time, then would stop and sit down. Laurie

TYRION

and Bernie would sometimes have to carry him back to the house. Bernie decided to get Tyrion a stroller so they could get him out to experience the world that he hadn't seen yet. Until Tyrion was more comfortable going on walks, he could often be found being pushed in his stroller by Laurie or Bernie through their neighborhood. Tyrion now walks about two miles a day without any issues.

After only a few weeks of fostering Tyrion, Laurie and Bernie couldn't imagine him with anyone but them. They adopted him and Tyrion became an official member of the family.

Tyrion enjoys meeting new people and loves making new human and dog friends. Unfortunately, not everyone wants to meet Tyrion. People still get nervous when they see him for the first time because of the way he looks. Some people make rude comments and others avoid walking near him. But more often than not, people love meeting and getting to know Tyrion.

Tyrion didn't learn how to play in his previous life. He doesn't understand when someone throws him a ball or toy. He *does* enjoy playing with clothes, however, and can sometimes be found stealing them when Laurie and Bernie are folding the laundry. He has also been known to pry the socks off their feet. Tyrion has been obsessed with smells since his nose was mended. Because of the damage to his muzzle, Tyrion sometimes makes a snorting noise that resembles that of a pig.

Tyrion is known by many in Pittsburgh and around the country. He has become somewhat of a mascot for Hello Bully. The organization has held several birthday parties for him where people have the opportunity to donate money and supplies in his honor to support Hello Bully. Tyrion even gets a cake just for himself at the events! He was Mr. July in the 2018 Pinups for Pitbulls calendar, and Laurie recently wrote a children's book about Tyrion's life after being rescued. She hopes that it will teach children that it doesn't matter what you look like in this world as long as you love and accept yourself for who you are. Profits from the book go to support the mission of Hello Bully.

Tyrion is the center of Laurie and Bernie's lives. They make sure he has the best experiences possible, day in and day out. He reminds them to be grateful, strong, and happy. It is imperative to Laurie and Bernie to continually help raise awareness and funds for pit bull–type dogs and those who rescue them.

"After only a few weeks of fostering Tyrion, Laurie and Bernie couldn't imagine him with anyone but them."

BEATRICE, KIMBERLY & STILTON

Beatrice was rescued by volunteers from Chicagoland Bully Breed Rescue (CBBR) in 2007. A teenage girl had brought the six-week-old pit bull into a pet supplies store and begged for help—her mother did not want a dog in the house and was forcing her to live in a bathtub. It is incredible that Beatrice survived away from her mother, being so young and without being bottle fed. CBBR volunteers brought her back to health, and by the time she was ten weeks old, she was a happy, playful, and healthy puppy.

Eevie and Matt, both social work professors at a university, adopted Beatrice and because of their love for her, began volunteering with CBBR. It broke their hearts knowing that others just like her were suffering all around them. With Beatrice's help, they began their volunteer work by fostering "throw away" dogs that had been found on the street.

Eevie met Kimberly, a beautiful fawn-colored pit bull who'd been on track to be euthanized, while volunteering with CBBR at a pet expo in 2011. She witnessed Kimberly greet hundreds of dogs and people that day with grace. Eevie knew that she was a special dog and brought her home that evening. Kimberly's exceptionally mild personality was a match made in heaven for Beatrice, who connected with her instantly.

Kimberly now joins Eevie's class Social Work and the Human/Animal Bond once a year to help students learn about assessing an animal's appropriateness and safety for various animal-assisted interventions. According to Eevie, an essential part of this

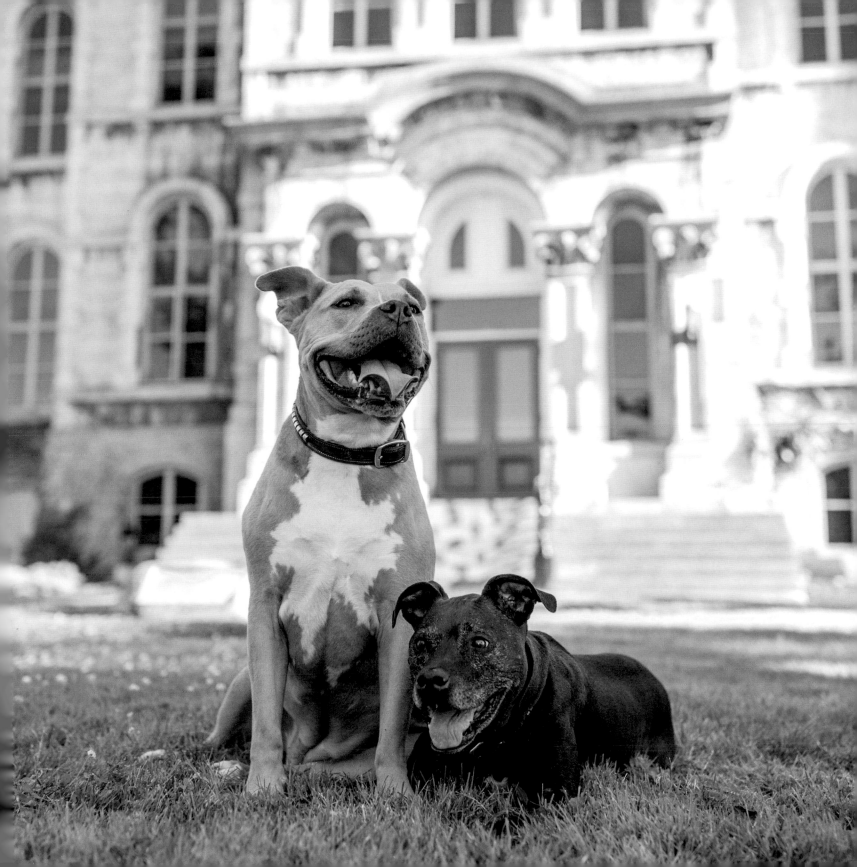

lesson is that one can't determine a dog's suitability for therapeutic use by its breed, size, or color. She points out that, "As with their human clients, social work students need to be open-minded when they assess animals based on their actual behavior, not relying on prejudices or assumptions."

Kimberly relishes the opportunity to be handled and tested by a room full of students, some of whom are fearful of dogs—especially blocky-headed pit bulls like herself. While Matt handles Kimberly, Eevie asks the students to interact with her in ways that mimic a range of potential clients and clinical settings. Students do unexpected things: they move strangely; they handle her paws and kiss her too hard; they drop a stack of books to measure her reaction. Of course, Kimberly remains unbothered and calm through it all. She's just unbelievably happy to be the center of attention in the classroom.

Kimberly is sunny, optimistic, and gentle. She becomes concerned when she hears a baby cry on TV; she doesn't know how to fetch because Beatrice always gets to the ball first. Some of her favorite activities are greeting every living thing with a wagging tail and getting belly rubs from strangers.

Beatrice is serious, devoted, regal, and athletic. She tends to eat when and if she feels like it—unless another dog looks at the food or treat; then it becomes the best food ever, and she eats it immediately. Beatrice loves cats and once helped groom Eevie and Matt's foster kittens. She enjoys fetching balls and Frisbees with Matt until she's exhausted.

In 2018, Eevie and Matt rescued another pit bull named Stilton. With Beatrice aging into her senior years, they thought it would be good for her to help raise a new rescue puppy.

Stilton is a bouncy and smart puppy who can't seem to sit still. He snores like an old man and squeals with joy when Matt enters a room. He loves walks with Kimberly, swimming in rivers, and jumping from the couch. Stilton is also an expert at dismantling stuffed dog toys. Beatrice and Kimberly fell in love with Stilton and wholeheartedly welcomed him into their pack the moment the three first met.

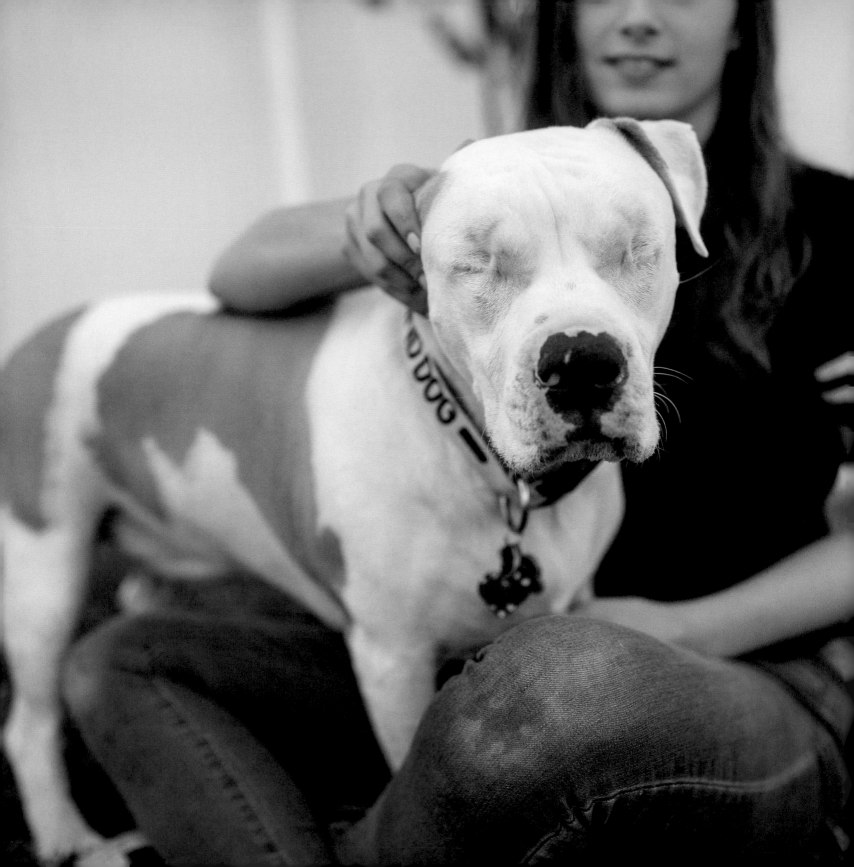

BEAR

In February 2016, a one-year-old pit bull named Bear was hit by a car and immediately rushed to an animal hospital outside of Philadelphia. His injuries threatened to leave him blind. Unfortunately, his owner at the time could not afford the surgeries and ongoing treatment Bear would require, so he was signed over to the veterinarian in charge of his care.

Days after Bear entered the hospital, Sarah, who worked there, called her daughter Katie and asked if she thought a blind dog was trainable. Katie, fifteen at the time, quickly came by to visit. She gently put her hand on Bear's head, and he let out a deep sigh. She and Sarah decided right then and there that they would adopt him and bring him home. Bear was in the hospital for about four days before it was determined that one of his eyes was too damaged and needed to be removed. The hospital staff tried to treat and save the other eye, but a few weeks later it was also removed, leaving Bear completely blind.

The first few days in his new home weren't easy. Bear was sad, confused, and cried when he wasn't sleeping. His first night, he rested his head up on Katie's bed and cried because he wanted her close to him, so she got down on the floor and spent the night next to him.

Once his pain medication began to wear off, Bear started to show some personality. He disliked his recovery cone collar and would wedge himself between the poles

BEAR

under Katie's bed to slide his head out of the cone. She once left Bear alone for five minutes and came back to find him with his head stuck inside a cereal box.

Years later, spend some time with Bear inside his home or backyard, and you wouldn't know he is blind. He maps out spaces in his head quickly. While he occasionally runs into doors, Bear manages to miss bumping into most things even if he's not familiar with the area. The first time he visited a relative's home, Bear walked right up to a wall then stopped and turned, despite no warning to him that the wall was there. He knows exactly where the couch, stairs, tables, and chairs are in his home, and will jump up onto Katie's bed without hesitation. After Katie rearranged her room recently, it only took Bear a few minutes before he knew how to navigate it anew.

In the backyard, Bear runs fast, avoiding sheds and the fence. His favorite toy is a ball that makes noises. He loves playing with his family's other dog, Reese. They wrestle, jump, and nip at each other as they fly through the backyard. Reese enjoys playing keep-away with Bear; she'll tap him with a stick and then run away. If he loses track of her, Reese will tap him a second time, so he knows where she is, and can begin chasing her again.

Bear has had a significant impact on Katie. Before he entered her life, she spent her days going to school, coming home, doing homework, and then watching TV. Katie had friends but didn't go out often and wasn't open to meeting new

people. Then Bear came into her life. Katie went from going through the motions to becoming a pit bull and disabled dog advocate, going on walks, talking to people online and in person, and getting more involved in photography.

Bear helps Katie with her stress. He seems to know when she's having a bad day and will insist on sitting in her lap. If Katie wants some space, Bear will nudge, paw, and lick her face until she makes room for him. No matter what she is doing, Bear is by her side, following her around. He's her best friend and Katie can't imagine life without him.

Bear loves meeting new people. If they approach slowly, he happily accepts their affection. Katie is always sure to tell people beforehand to approach gradually and gently place their hand in front of Bear's nose so he can smell them. Because he can't see who is nearby, Bear can be a little hesitant. Once he's comfortable, he loves kissing his new friends.

Katie loves sharing Bear with the world through his Facebook and Instagram pages. She enjoys showing everyone that dogs are inherently good and that they all need homes, regardless of looks or disability. Katie doesn't want others to fall for the false stereotype that pit bulls are dangerous dogs. She wants people to know that regardless of ability, dogs can live a happy and healthy life. Katie hopes that the more she shares Bear with the world, the more people will be open to saving a pit bull or an animal with a disability.

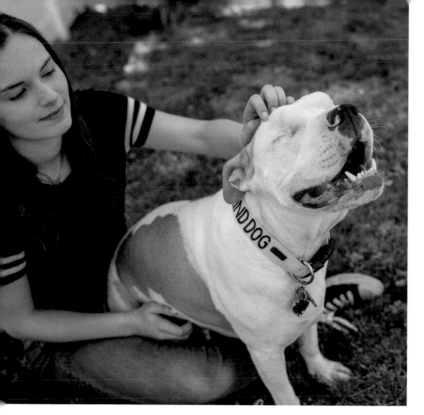
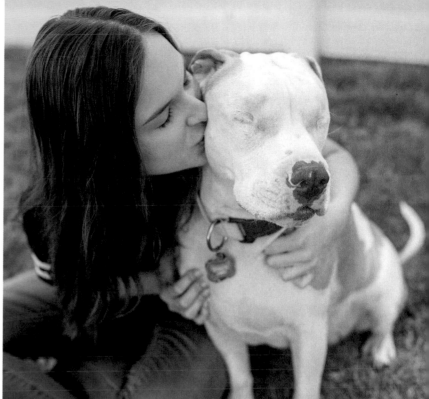
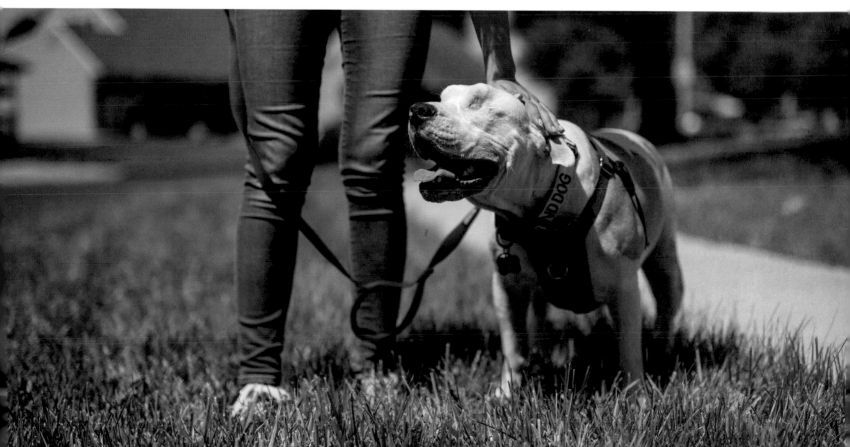

LEXY

Much of Lexy's first eight years of life were spent as a breeding dog for a backyard breeding operation near Vancouver, British Columbia. She was found neglected and in terrible condition. She was skinny and her belly was nearly touching the ground as she walked. Based on her condition, it was likely that she had never been outside to experience the world. City noises terrified Lexy, and she didn't even react to the words "walk" or "treat."

Jenny and Lexy first met when Jenny came to the British Columbia SPCA seeking a companion for her rescue mix, Pete, whom she'd also adopted from there. Pete was hurting from some medical issues, and Jenny was hoping a new companion would lift his mood. Unfortunately, because their energy levels were so different, Jenny felt that Lexy and Pete would be incompatible. Jenny left the shelter that day without a dog, but hoping that Lexy would soon find her forever home.

One week later, Pete passed away. At that same time, Lexy had been moved to foster care to help boost her spirits after being in the shelter for many months. Jenny began visiting Lexy and decided to adopt her just a month later. In all Lexy's months at the rescue, Jenny was the only person to submit an adoption application for her. She saw a dog that deserved love in her life and wanted to be the one to give it.

With time, Lexy began to grow healthy and open up to the world as she became more comfortable with living the city life in Vancouver. Lexy loves visiting the beach,

"In addition to being an ambassador for pit bulls, Lexy is a powerful voice for senior rescue dogs."

LEXY

which is only a few blocks from their home. She enjoys swimming, jumping into the water, and racing after the Frisbee. Lexy always manages to carry the Frisbee all the way home, like it's a prize.

In the winter, her favorite place to visit is the space right in front of their fireplace. All she needs is a blanket and Bruce, a plush shark toy who has been her best friend for more than four years. Lexy had never acknowledged toys before, then one day at a local pet store, she grabbed the shark toy, and they've been attached ever since. Bruce has become a security blanket for Lexy and keeps her safe from loud trucks speeding down the street and during fireworks. When Lexy needs a quiet moment by herself, she takes Bruce with her and cuddles up next to him.

Lexy has quite the social media following under the moniker "Lexy the Elderbull." In addition to being an ambassador for pit bulls, Lexy is a powerful voice for senior rescue dogs. In January 2018, Lexy turned twelve years young, and Jenny focuses a lot of her attention on educating people that age is just a number. According to Jenny, the key is healthy and balanced foods, outdoor activities, and lots of love and support. Lexy is healthier and happier now than when she was rescued more than five years ago.

Jenny promotes three things through Lexy's social media accounts: adoption, senior dogs, and supporting rescues and shelters through activism, fundraising, and education. Over the years people have told Jenny that they view pit bulls differently because of the work she and Lexy do. Their advocacy and educational website, LexyTheElderbull.com, has raised more than nine thousand dollars for pit bull rescue organizations throughout the US and Canada. Lexy also has a modeling career, and flew from Vancouver to Philadelphia to be photographed for the 2019 Pinups for Pitbulls calendar.

Lexy is very sweet, curious, and intelligent. She has managed to figure out how to open the refrigerator and will sometimes store blocks of cheese in the couch for eating later. Lexy believes that laps were put on this earth solely for her to sit on. She also likes to snuggle next to Jenny and have her hold her paw. Her favorite treats are blueberries, dried tripe, and she even gets ice cream on special occasions, like book photo shoots!

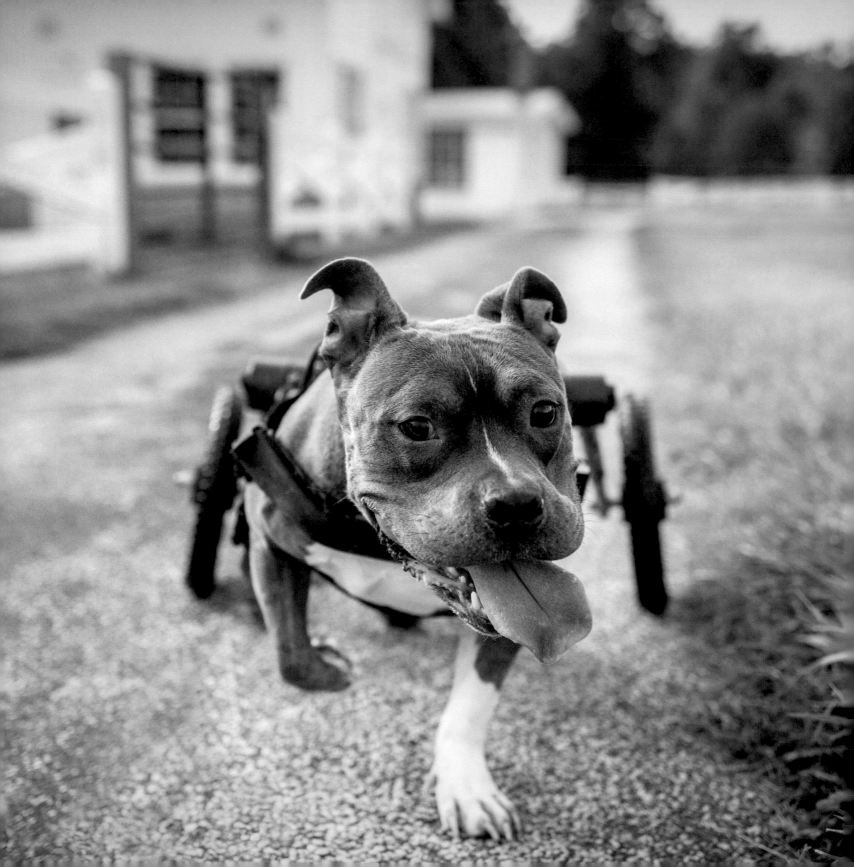

CHAUNCY

On the eve of January 18, 2016, three people entered a veterinary clinic in the Cleveland, Ohio, area with a pit bull. They reported that he had inexplicably lost the ability to move his back legs. However, when questioned, they admitted to physically disciplining the dog. The technician left the room for a moment, and when she returned, only the dog was there. The people had abandoned him and had given fake contact information on the intake paperwork.

The veterinary staff cared for the dog for several days. They eventually determined that a neurological injury to his spine negatively impacted the use of his rear legs and it would require costly diagnostics to gather more information. A local rescue organization jumped in to take care of him during his recovery and named him Walter.

On Valentine's Day 2016, a fundraiser was held at a local pet boarding facility to help with the costs associated with Walter's care. As the event was being advertised on social media, a veterinarian named Laura learned about Walter. Laura specializes in acupuncture for dogs and understands the positive effects the treatment can have on neurological issues. Because of this background, Laura became interested in Walter and his story, so she and her husband, Michael, decided to attend the fundraiser.

When Laura and Michael arrived, they could see that Walter was distressed. The room was packed and people were crowding around to take photos with him. As a veterinarian, Laura was concerned to see that this dog was not being cared for properly. Suddenly Walter broke away from his handler, dragged himself across the floor from the other side of the room, and stopped right in front of Laura and Michael. An attendee even accused Laura of having treats in her pocket (she didn't) as the reason Walter went directly to her.

CHAUNCY

Because of the instant connection they felt with Walter, Laura convinced the rescue organization caring for him to allow her and Michael to foster him. Shortly after the fundraiser, MRI results determined that Walter had significant damage to his spinal cord, and no surgery could be done safely to correct it. Laura and Michael quickly got to work addressing his medical and emotional needs, and in a month's time they adopted him and renamed him Chauncy. While Laura and Michael were not planning to add to the three pit bulls they had already rescued, they felt Chauncy needed them and knew they could provide the long-term care he required.

Chauncy's initial physical therapy consisted of acupuncture, laser therapy, underwater treadmill therapy, land exercises, electrical stimulation, and range of motion exercises. Most of these things occurred either daily or several times a week for months starting in March 2016. Today, Laura and Michael focus more on strengthening and range of motion exercises to keep Chauncy healthy and as mobile as he can be. While his back legs aren't paralyzed, he has severe weakness and lacks coordination from the damage to his spinal cord. He can stand for short periods of time but loses his balance quickly.

Chauncy didn't know how to use the wheelchair very well when Laura and Michael first brought him home, but he picked it up quickly and can even outrun Laura in it now! The other three dogs (Olive, Poppy, and Butter) get out of Chauncy's way because he tends to run everyone and everything over. Even with his wheelchair, Chauncy completed a basic obedience class in the summer of 2018. He loves to spend time on the couch with Laura, Michael, Olive, Poppy, or Butter. During the winter months, you can often find him laying in front of the fireplace. Chauncy also enjoys running laps around the chicken coop in pursuit of a chicken that he'll never catch. His favorite treats are pita chips and anything hidden in one of his food puzzle toys. He enjoys the company of plush toys, especially a pink stuffed pig that he's very fond of.

Chauncy has made quite the impression on the lives of Laura and Michael. Michael comes home at lunchtime Monday through Friday to take the dogs outside. He carries Chauncy up and down the steps every day so that he's not separated from the other three dogs.

Chauncy has encouraged Laura to build upon her eighteen years of veterinary medicine experience. As they provided rehabilitation for Chauncy without any real training, Michael and Laura realized how much their neighborhood lacks services for Chauncy and other dogs with rehabilitative needs. Laura wanted to do something about this, so she became certified in acupuncture and then moved on to become certified in canine rehabilitation. She is currently pursuing a post-graduate program in spinal manipulation and chiropractic care. Laura hopes to one day provide her clients with full-service veterinary rehabilitation and help other dogs with mobility dysfunction, like Chauncy.

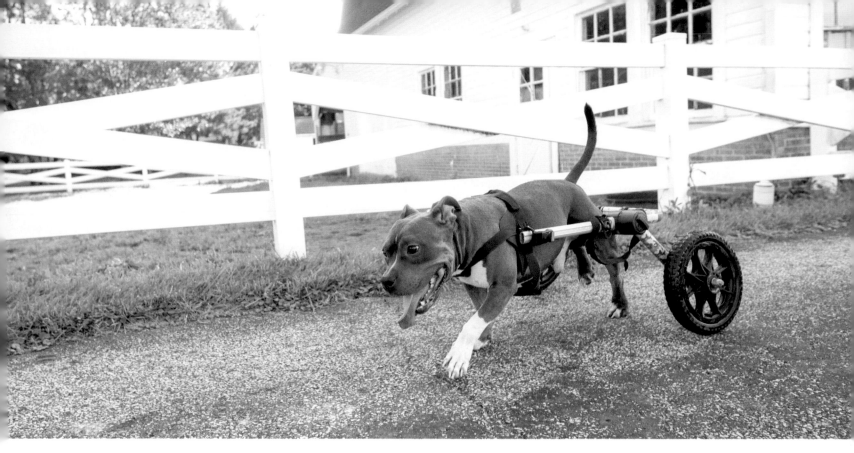

"Michael and Laura realized how much their neighborhood lacks services for Chauncy and other dogs with rehabilitative needs. Laura wanted to do something about this."

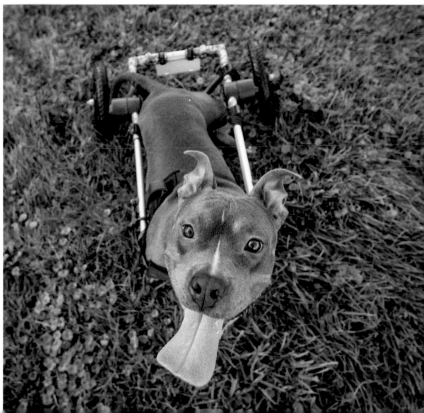

PENNI

Penni spent her first year or two in a basement, where her owners physically and verbally abused her. Luckily, she was picked up as a stray by a police officer in the Bronx one day and taken to the local pound. Soon after, Penni was evaluated and put on the euthanasia list at the overcrowded pound because her extreme fear of everything made her seem unadoptable; they viewed her as hopeless.

Luck struck again when Fur Friends in Need stepped in at the last minute and rescued Penni so they could rehabilitate her and eventually adopt her out to a family.

When Blaine met Penni in 2014, he was warned by the volunteers at Fur Friends in Need that she was very timid and startled by most everything. Blaine sat down on the sidewalk to give Penni space and make her more comfortable. Without pause she walked up to Blaine, sat in his lap, and began to lick his face. It was clear to everyone that Penni had found her forever home.

Blaine lived in a busy New Jersey town. After adopting Penni, taking her outside of the house was difficult because she was still a very fearful dog. She often spent her time outside shaking in fear. Blaine felt helpless. He decided to change the setting for Penni and take her to a secluded forest area outside his town. She immediately responded to the new environment. She was a completely changed dog when they were in the isolation of the forest: Penni became relaxed, happy, excited, confident, curious, and adventurous.

PENNI

Blaine and Penni moved to Las Vegas about a year after becoming a family because of a job promotion for Blaine. While Las Vegas wouldn't seem to be the best fit for a dog like Penni, there is a significant amount of accessible and beautiful outdoor space just outside the city limits. It turned out to be the perfect fit for Penni.

As Penni's passion for being outdoors on the trails became more and more evident to Blaine, he realized that they could go just about anywhere together. Mountains, canyons, rivers—it didn't matter. Penni's self-confidence was reaching new heights on a daily basis, and they kept pushing the boundaries together.

Blaine even purchased a safety harness specifically designed for dogs so they could safely travel even more treacherous terrain together. They began by testing it in their backyard; Penni was comfortable and didn't mind the harness at all. Once he felt Penni was ready, Blaine and his adventure-seeking friends worked together to transport her over rock walls using the harness successfully and safely.

In Blaine's mind, the next logical step when it came to Penni's adventures was rappelling off a much higher cliff. Their first rappel was an enormous adrenaline rush for the both of them. Penni was hesitant to walk off the cliff's edge the first time, but was comfortable on her second time when she stepped off the cliff on her own. Blaine often has to slow her down because she is so eager to jump once her harness is on and secured to him.

Penni has undergone a significant transformation from when she was rescued from the pound. Her most debilitating characteristics have disappeared over the past couple of years. While some timidity remains when she is indoors, it vanishes when she's outside. Blaine will continue to make her a part of as many outdoor adventures as he can.

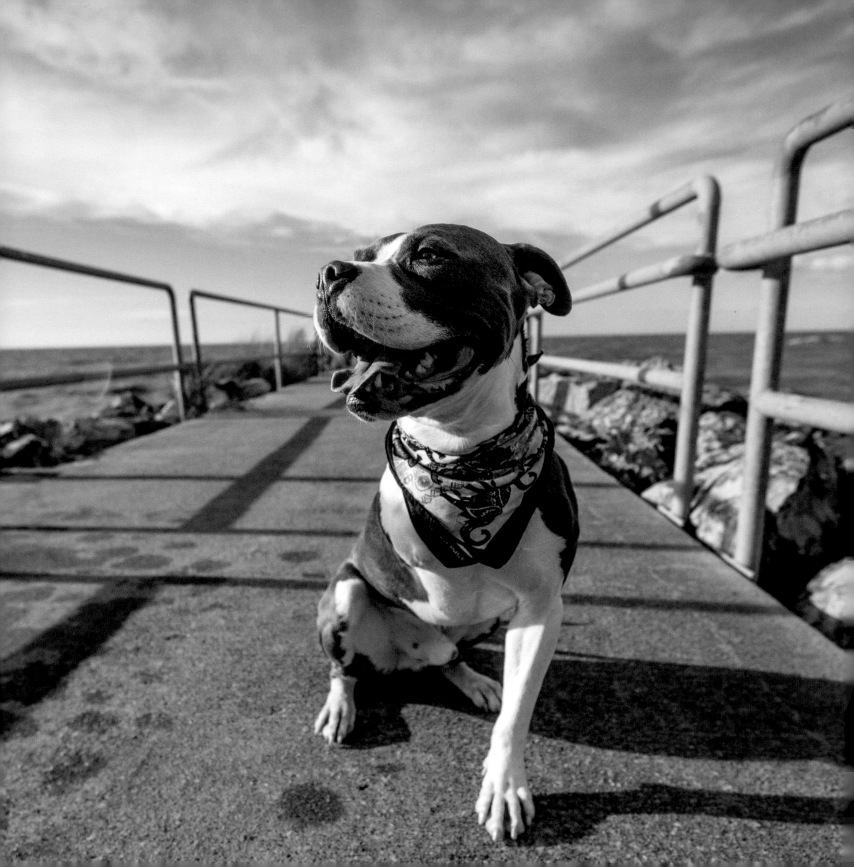

GIBSON

Gibson was found severely injured and underweight on the streets of Cleveland, Ohio, in January 2017. Bullets had shattered the bone and joint in his right front leg. Because of the severity of his injuries, the veterinarians working on Gibson had to amputate his leg three days after he was found.

Love-A-Stray dog rescue, a nonprofit organization run entirely by volunteers, was eager to help. They were able to take Gibson under their care and place him in a loving foster home. Once he healed from his surgery, Gibson began physical therapy several days a week at a rehabilitation facility for pets. Some of his treatment included working with a wobble board, jumping hurdles, and aqua therapy in an underwater treadmill built just for dogs.

Cayla, a rehabilitation specialist at the rehab facility, spent three days a week working with Gibson. The two developed a close relationship because of all the time they spent with each other. Cayla, who loved working with all the dogs at the rehabilitation center, was especially excited on the days she knew she would be working with Gibson. She was surprised and charmed by his quirky personality, big smile, and determination to get stronger each day.

When it was decided that Gibson was healthy enough to be adopted out to his forever human, Cayla was a natural candidate. She knew him, knew his needs, and had already developed a powerful bond with him.

GIBSON

Cayla has always loved pit bull–type dogs but her boyfriend, Corey, didn't trust them because of negative stories he had seen on the news. He didn't have any intention of meeting a pit bull or having one as a pet. When Cayla brought Gibson home to meet Corey in person and to show him how amazing pit bulls truly are, his mind was changed immediately!

After fostering Gibson for a short period of time, Cayla adopted Gibson on July 23, 2017 and welcomed him into her family with Corey and their other dogs.

Gibson now has three dog siblings: Abby, Missy, and Jenna. Cayla describes Abby, a rescued twelve-year-old English lab, as a "crabby old lady." When she gets crabby, Gibson knows to leave her alone, but when she's in a good mood, Abby and Gibson love to cuddle and play together. Missy, the rescued seven-year-old yellow English lab, is Gibson's best friend. Missy and Gibson are inseparable. They stay at each other's side most of the day. Missy loves to kiss Gibson all over. Jenna is a seven-year-old Cavalier King Charles spaniel. Gibson instantly connected with Jenna—their easy bond was the reason Cayla and Corey ultimately knew Gibson was right for their home and chose to foster him in the first place. Gibson and Jenna love to chase each other and play and tug-of-war.

Gibson and Corey are now best friends and Gibson has completely shifted Corey's perception of the misunderstood "breed." Now when Corey spots pit bulls in public, he is eager to meet them instead of being distrustful toward them.

Despite all that Gibson suffered, he approaches everything with a great attitude. He still receives physical therapy at least once a week, often exercising in the underwater treadmill. In some way or another, he will have to undergo physical therapy for the rest of his life. But Gibson doesn't let his amputation slow him down; he can do just about anything a four-legged dog can do. He loves to play, sunbathe, wrestle, nap, snuggle, play tug-of-war, and go on walks with his humans. He has to wear a customized brace every time he goes for walks to help prevent him from injuring his only front leg. Gibson loves to face dive onto the carpet, flip onto his back, and roll around while kicking his legs in the air. His favorite treats are frozen peanut butter–filled toys and bully sticks.

Because of the positive impact Gibson has had on every member of their family, humans and dogs alike, Cayla and Corey look forward to rescuing more pit bull–type dogs in the future.

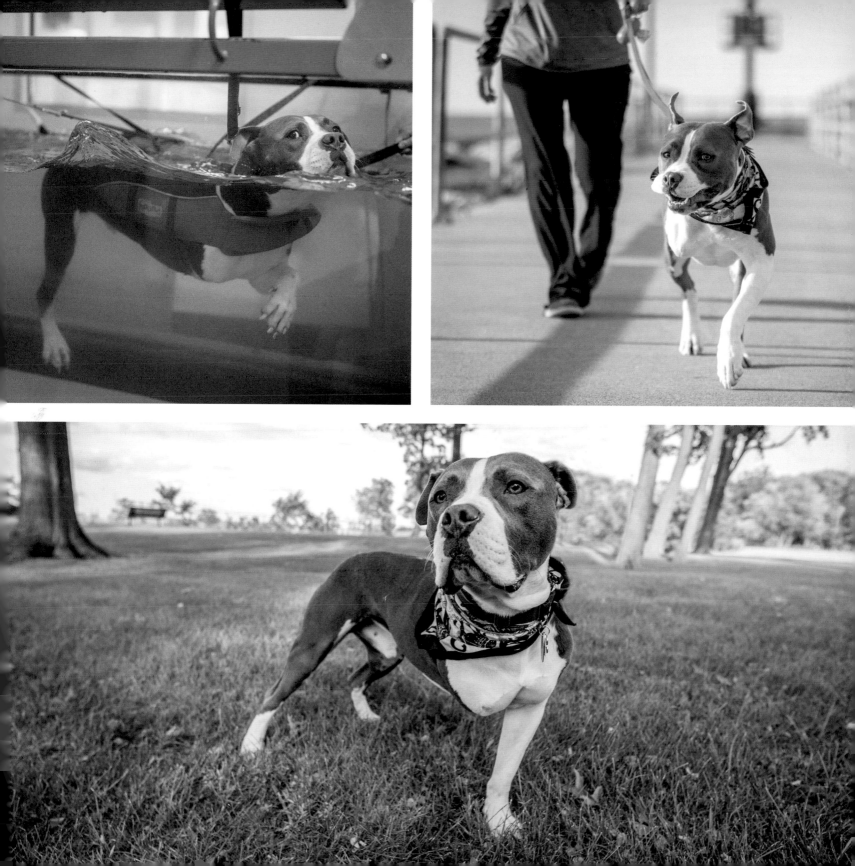

LOLA

Lola spent the first eight years of her life chained to a wall, living on a dirty garage floor in Brooklyn, New York, with no protection from the elements. In 2016, Angels for Mistreated Animals (AMA) became aware of her situation and convinced Lola's owner to surrender her to the rescue.

When Lola came to AMA, she was dirty and had several tumors including a large one on her hind leg. Fortunately, the organization was able to provide her with the treatment she so desperately needed. Following her recovery, AMA made a YouTube video about Lola's life and rescue which quickly went viral with more than two million views. Her sad story caught the attention of many and 350 people applied to adopt Lola in a short period of time.

Six months earlier, a New York resident named Charlene lost her dachshund, Sebastian, to old age. She was immediately smitten when she saw the video of Lola online. While she was still grieving the loss of her dog, Charlene was ready to welcome a new one into her home.

Lola's face made Charlene smile. She thought Lola looked grateful for those that rescued her. Charlene reached out to AMA, but told them to adopt Lola to someone else once she found out how many people wanted to adopt her. Charlene was ready and willing to adopt a dog with less interest who also urgently needed a home.

AMA had other ideas. They had a gut feeling about Charlene and asked that

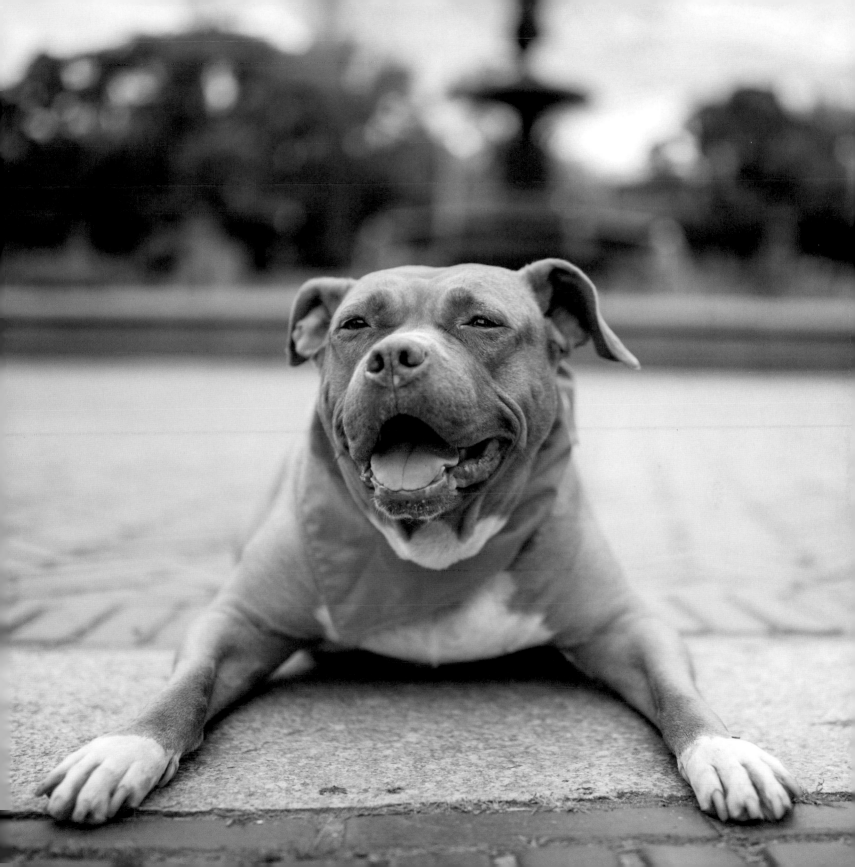

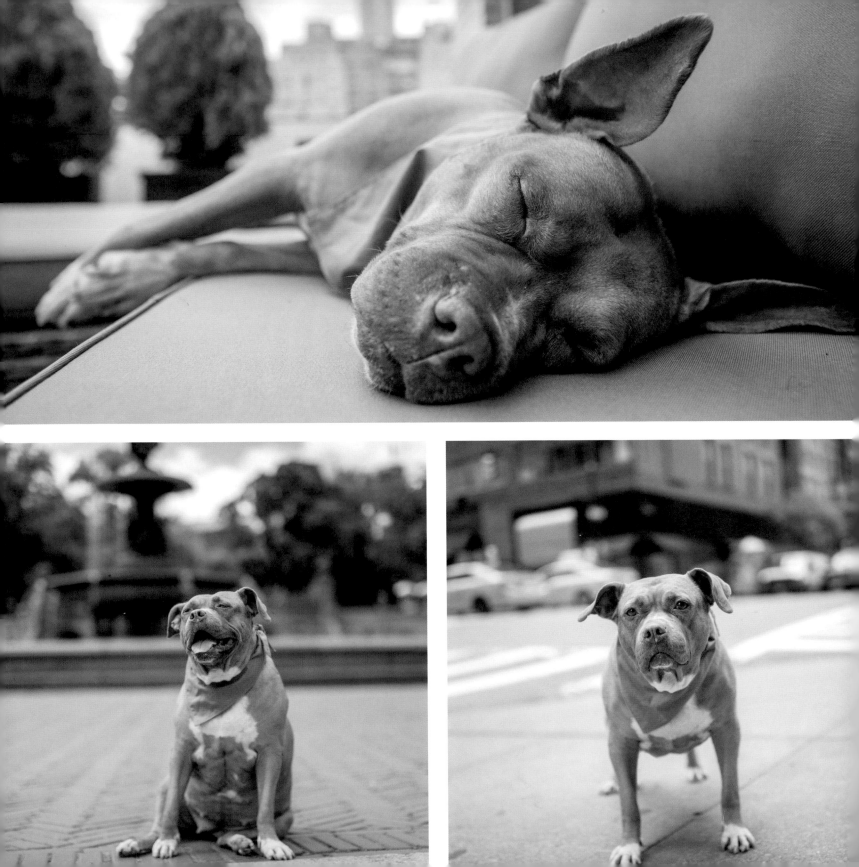

she be the one to adopt Lola. So Charlene picked Lola up that weekend and brought her back to her apartment, just a block away from Central Park.

Lola is clingy. She likes to know where Charlene is at all times in the apartment. If Lola sees her packing a bag, she rushes over to it and waits, making sure Charlene knows to take her out too. Lola is confident most of the time, like a wise old lady. She is loving and relaxed. She lets Charlene and her vet do just about anything to her that is necessary. The vet can draw blood, clip her nails, and look into her eyes and ears without any resistance from Lola.

Lola is constantly spoiled. Charlene's life revolves around making sure she has the best experiences possible. Lola spends much of her time sleeping, exploring Central Park, taking impromptu naps in the middle of walks, and playing with her best friend Black Bean, a small rescue mix that lives with Charlene's mother in Connecticut.

When they visit Central Park, Lola chooses whether they enter on 67th or 69th Street. Once they enter, Lola likes to take a break near the benches and watch everyone go by. It's one of her favorite things to do.

Lola loves humans, especially children and babies. Often, they want to say hello to Lola, but their parents don't let them because she's a pit bull. If Charlene hears or sees this happening, she always tells them it's okay and that Lola is very friendly. Sometimes they approach cautiously but always end up falling in love with her, which warms Charlene's heart. Lola loves the attention and sometimes thanks the children for their affection with a slobbery kiss.

From being chained up on a dirty garage floor to sunbathing on a NYC balcony with a view, Lola is now living the life she deserves.

ASHLEY

Ashley is one of the 367 dogs rescued from the second largest dogfighting bust in US history on August 23, 2013. It is not known if she was used only for breeding or for breeding *and* fighting; based on the condition of Ashley's body when rescued, she was overbred and she also has some scarring consistent with dogfighting.

Daisy, Hello Bully's president, transported Ashley back to Pittsburgh in Spring 2014. The two had to stay overnight in a hotel and it was the first time Ashley slept in a bed. The two had a double-queen room and the only place Ashley would settle was on Daisy's pillow, right next to her face. It was that night that Daisy realized Ashley loved humans, despite the people who harmed her in the past, and that she snored very loudly.

On intake, the vets examined Ashley and determined she was pregnant. She was given a private suite at Hello Bully's shelter with a kiddie pool, blankets, and pillows in preparation for her labor. Ashley kept growing, and the shelter staff began to worry because the puppies weren't coming. The vets did an ultrasound to investigate and found no puppies! Ashley had a "false pregnancy," for which she even produced milk for the puppies she, too, thought were coming. False pregnancies are a common result of exploitation and overbreeding.

Anna first met Ashley as a volunteer at the temporary shelter that the Humane Society of the United States had set up for the dogs rescued from the dogfighting

ring. Anna got to know Ashley even more as a volunteer at the Hello Bully halfway house in Pittsburgh where Ashley was transferred. Anna took Ashley on a few weekend kennel breaks, and during one of those weekends, Ashley was introduced to Anna's four-year-old nephew. Ashley was amazing with him, and continues to love all the children she meets. It was an easy decision for Anna to adopt Ashley once she was deemed ready by the shelter for her forever home.

Anna and Ashley participate in a life skills summer program for underprivileged, special needs youth in the Pittsburgh area. Anna talks to the kids about caring for pets and volunteering, and she discusses how people quickly judge pit bull–type dogs based on appearances. She works with the kids to relate unfair judgments to their own life experiences. The last time Anna and Ashley attended the program, they made dog toys with the kids. Ashley usually spends her time soaking up the attention the kids give her. One of the kids will often take her leash and lead her around. In some instances, kids who were previously terrified of dogs approach Ashley and fall in love with her.

Ashley loves meeting new people! There have been times when a visitor to Anna's house has been afraid of Ashley because she sits in the bay window and appears much larger than she actually is. Of course, once they meet her, they all fall in love with Ashley, everyone from the men who installed her windows to the plumber. Anna sometimes wonders if she ends up paying extra for the time the workers spend with Ashley instead of fixing her house!

Ashley is Anna's best friend and a significant part of her family. She is a grandchild to her parents and cousin to her nephews. She always goes to family functions with Anna, especially all of the holiday gatherings. Anywhere that Anna can take her, Ashley goes.

"Anna and Ashley participate in a life skills summer program for underprivileged, special needs youth in the Pittsburgh area."

JAMES

In March of 2017, a stray dog roaming the streets of Cleveland was hit by a car and then beaten by a group of men, leaving him severely injured with multiple broken bones. The dog's story was shared by just about every news outlet in Northeast Ohio. He was quickly taken to the Cleveland Animal Protective League (APL) to manage his recovery and future adoption. The staff named him Indiana Bones.

The Cleveland APL took Indiana Bones to an animal wellness center the following month to see what treatments could assist with his post-surgery recovery. He had a significant amount of muscle loss, and his mobility was impaired due to broken leg bones. Dr. Neal, the owner of the wellness center, fell in love with Indy during the first appointment. For days after that visit, he would bring Indy up with his wife Stephanie, often showing her pictures and news articles about Indy.

At that time, Neal and Stephanie had a fourteen-year-old greyhound named Sweep. Adopting another dog wasn't part of their plan but Stephanie quickly realized that there was something special about Neal's connection with Indy that she hadn't seen before.

Indy's forgiving and trusting nature drew Neal in. He fell in love with his silly demeanor and playful attitude. Despite the pain and abuse he endured, Indy was still loving and eager to make new friends. He had every reason to be scared and withdrawn, but there he was: trying to wag his tail and give kisses even though he could barely move around.

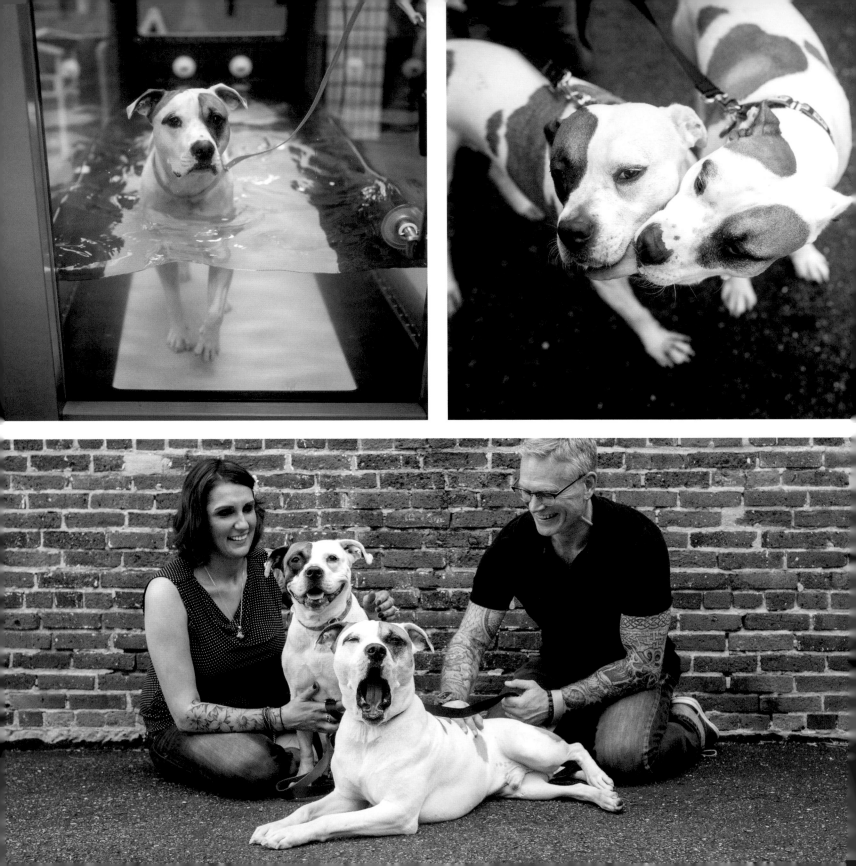

JAMES

Indy spent much of his post-surgery recovery time at the Northeast Reintegration Center (NERC). NERC helps women offenders as they prepare to enter the community after serving time in prison. Indy was assigned to a resident named Nikki who acted as his foster mom. She massaged his legs, provided range of motion exercises, and took him for walks to build up his strength. Nikki took excellent care of Indy during the first couple months of his initial recovery, even letting him sleep in her bed.

Once Indy was recovered, Neal and Stephanie decided that they would ask about adopting him. Indy's story had been all over the local news which led to hundreds of adoption inquiries. A week after their inquiry, the Cleveland APL approved Neal and Stephanie to be Indy's forever humans. Given that Neal and Stephanie had already grown attached to Indy and could continue to provide needed and free therapy for the rest of his life, the APL was confident that they would be the best fit for Indy. With a fresh start in life came a new name: James.

The APL hosted their annual fundraiser telethon that September and borrowed James for the day to feature during the broadcast. A live video of the event was streamed on the computers at Neal and Stephanie's wellness center. During one segment with lots of dogs running around, Stephanie and Neal noticed a dog dart across the screen that looked very similar to James. It turned out that the APL had named the dog "Lady Indy" because of her resemblance to James. Their senior greyhound, Sweep, had passed away and they wanted a companion for James and thought Lady Indy might be a perfect match. Two days later, the dogs successfully met for the first time, and she came home with them that day. They named her Lorna.

James and Lorna love each other. They tug toys between them and race around the house together. When they're finished, they cuddle up and fall asleep together. When James is in the treadmill for his exercise at the wellness center, Lorna paces and whines until he comes back.

Neal and Stephanie work hard to keep James at a healthy weight to reduce stress on his hips and knees. He has hydrotherapy sessions four times a week in a water treadmill. The resistance of the water helps maintain his muscle mass and stabilize his hind end. He also gets monthly Reiki treatments. These measures will likely be in place for the duration of James' life.

Stephanie and Neal believe James would forgive the men who beat him. His heart spills over with love; he isn't capable of holding a grudge.

SOMETIMES CARL

When Eric visited a Florida shelter in 2011, he intended to rescue a cat. Instead, he came home with Chase, a one-year-old pit bull mix puppy. Chase had been adopted and returned to the shelter multiple times for being too active and rambunctious. You read that correctly—Chase was returned for acting like a puppy. He won the human lottery when Eric chose to adopt him, and together Eric and Chase welcomed another human to the family when they moved to New York City: Eric's girlfriend, Katie.

When he is in the mood to be extra silly and unpredictable, Chase becomes Carl. You may know him on social media as "Sometimes Carl." Carl can strike at any time. Eric and Katie might be watching TV, and Chase will flip over on this back in front of them, with all four paws in the air. That's Carl. Or they might come home to the apartment to find him sitting on the couch like a human. That's also Carl. When his giant tongue is hanging out of his mouth and he couldn't care less, that's Carl too.

Chase is not only an ambassador for pit bulls, but rescue dogs of all types. He can often be found serving as big brother for the puppies his humans foster in their New York City apartment. Eric and Katie have fostered thirteen puppies since 2015. The foster puppies often enjoy chewing on Chase's ears and jowls. He's very tolerant and enjoys showing them the ropes of living in and exploring the Big Apple, even if they steal his toys and humans' attention at times.

Chase also loves to kiss. He even participated in the pit bull kissing booth for an annual fundraiser, where humans made donations to a local animal rescue organization in order to get kissed by Chase in return.

On top of his social media fame and serving as an ambassador for pit bulls and other rescued dogs, Chase also has a career in television. Thanks to his online fame, he's made multiple TV appearances, including on the *Today Show* where top influencer dogs helped showcase pet safety products. Chase modeled a car travel harness and was unfazed by all of the bright lights and strange people around him during the filming.

When he's not being Carl, Chase is a lazy, sweet, happy, and attention-seeking dog with little respect for his humans' personal space. He loves to be close to them so he can snuggle, in hopes of getting belly and head rubs.

MIRA

Mira came to Pits for Patriots from a high-kill shelter in southern Illinois, where many dogs are euthanized unless rescue organizations pull them out. When the Pits for Patriots founder met two-year-old Mira at an adoption event near Chicago, she immediately knew that Mira had the temperament to be a great service dog. She was social with all types of people, but also calm. Mira liked other dogs but paid more attention to her human handler and exhibited a desire to learn and work. She wanted nothing more than the approval, love, and companionship of every human she met.

Mira was transferred to Pits for Patriots in 2012 and began her training to pass the Canine Good Citizen (CGC) exam and earn her therapy dog certification. These were required by Pits for Patriots prior to beginning service dog training. During training for her certifications and exams, Mira spent time with children on the autism spectrum at a Chicago-area nonprofit that serves those impacted by the developmental disorder. Mira's presence helped the children to calm down, focus, and become more engaged and communicative.

Mira went on to attain her necessary certifications and begin service dog training. During training she learned obedience tasks to mitigate her future handler's disability. As a dual-purpose service dog in mobility and post-traumatic stress disorder (PTSD), Mira can open and close doors, retrieve dropped items, and alert to anxiety. Mira participated in more than 120 situational sessions at restaurants, movie theaters,

MIRA

banks, grocery stores, and school functions during her service dog training.

In December of 2015, Mira was matched to Jonathan. Jonathan spent fourteen years serving in the United States Marine Corps and the National Guard. Due to injuries and PTSD, he was medically retired in 2016.

Mira can assist Jonathan with picking up and carrying items, opening and closing doors, retrieving his cane or keys, bracing, and alerting to his anxiety. Mira was trained to look for physical signs of stress such as hand-wringing, foot tapping, hand tapping on the knee, shaking, rocking back and forth, crying, or frustration. When Jonathan displays any of these symptoms, Mira nudges his hand repeatedly until the behavior is interrupted. She is also trained to apply lap pressure for deep-pressure calming if needed. Mira is attentive to Jonathan's every need, and they make a fantastic team.

After returning from Afghanistan in 2009, Jonathan became a member of the Veterans of Foreign Wars of the United States. With the help and companionship of Mira, Jonathan helps to guide other veterans to available programs when they return from duty. Mira has helped Jonathan along the way by easing his anxiety, which enables him to travel more, speak in public with confidence, and engage with other veterans and politicians in a way that wouldn't be possible without Mira at his side.

GINO

Gino's story starts with a pit bull named Gordon. On August 6, 2008, a dog was struck by a van in front of the office of a man named Matt Zone. The van crushed the dog's back leg and tail. Matt, a councilman for the city of Cleveland since 2002, reached underneath the van to calm the stuck and injured dog by putting his hands around its face. The dog let out a large gasp of air, as if relieved that someone was there to help him. Matt and the dog bonded immediately.

When the dog warden showed up to take the dog to be examined and held for three days to see if the owner would claim him, he told Matt that the dog would be put down if not claimed because he was a pit bull. At that time, the city of Cleveland euthanized unclaimed pit bull–type dogs. Matt immediately objected to this protocol and took the dog to a vet himself. He named the dog Gordon, paid for his vet bills, brought him back to health, and officially adopted him. While Gordon passed away only four years later, he would play a significant role in the future of animal safety and pit bull–type dogs in Cleveland. In June 2011, in part due to Matt's leadership, Cleveland's current breed-neutral vicious dog ordinance was unanimously adopted: Cleveland's ordinance changed the focus of the vicious dog label from the breed to the behavior of the dog. Because of Matt, Gordon's influence on him, and other city leaders who stepped up to make positive change, Cleveland no longer has breed-specific laws.

GINO

In January 2013, Matt and his wife, Michelle, became aware of fourteen pit bull puppies living in a basement in the Stockyards neighborhood of Cleveland. Still feeling the loss of Gordon only five months earlier, they decided to investigate the situation. All of the dogs, including the mother, father, and puppies were living in wretched conditions. The puppies had never left the confines of the basement cellar for the first sixteen weeks of their young lives. Matt and Michelle rescued the shyest and most timid one and named him Gino.

Gino loves to chew bones, rolled up sock balls, stuffed animals of any type, and balls. His favorite activities include going on walks with Matt and Michelle, sunbathing, and getting his tummy and ears rubbed. Gino enjoys sleeping and can almost always be found relaxing at Michelle's side when he's in the mood to snooze. When he's not sleeping, Gino will typically be at Matt's side. If Gino becomes tired before Matt or Michelle are prepared to turn in for the night, he starts to pout and make a fuss until one of them goes into their bedroom with him. During the summer, Gino spends the majority of his time in the backyard and loves to hang out with his best dog friend and next door neighbor, Coda. Gino is a very dedicated, loyal, and friendly dog.

Gordon and Gino have inspired Matt and Michelle to advocate not only for pit bull–type dogs but also for all the dogs of Cleveland, Ohio. Matt has been advocating for a new kennel to be built in Cleveland since 2008 when Gordon came into his life. The kennel that has been used since 1977 became only an adoption center a couple of years ago thanks to some fantastic and dedicated staff and volunteers. Before that, it was a holding center where many of the dogs were euthanized, especially pit bulls.

In January of 2019, a new state-of-the-art, 16,000 square foot city kennel opened in Cleveland thanks to Matt's leadership on the issue. It incorporates current best practices into the design, and most importantly, the facility promotes animal health and wellness while putting the dogs in the best position to be adopted into great forever homes. And of course, the kennel is located in Matt's ward on the northwest side of Cleveland. Gino continues Gordon's legacy of inspiring Matt to do more for the dogs of Cleveland, Ohio.

LUCKY

Lucky was surrendered by his owner at the Carson Animal Care Center in Carson, California, in 2015. Three years old at the time, she was surrendered with her nine-month-old sibling who was also a pit bull mix. The puppy was quickly adopted, leaving Lucky alone in the shelter. Shortly afterward, the shelter was contacted by the Samadhi Legacy Foundation in Las Vegas who offered to take Lucky under their care.

She was taken to a local vet for a health certification checkup, during which the vet discovered a broken hip. This meant Lucky would have to stay in California for surgery before relocating to Las Vegas. The Samadhi Legacy Foundation reached out to their friend Lisa Potiker, an education specialist and teacher in Southern California, to be a short-term medical foster while Lucky recovered from her surgery.

The medical foster period lasted about two months but Lisa continued to foster Lucky for another four months. Lucky loved Lisa's family dogs and started showing some selectivity and excitement issues with new dogs. Lisa was becoming attached to Lucky and worried that she may not be successful in another home because of her behavioral needs. In Lisa's mind, the new family needed to be perfect. It eventually occurred to her that Lucky was *already* in her forever home. She asked her husband if Lucky could be her "Valentine," and the family officially adopted her on Valentine's Day in 2016.

Lucky is a very expressive and happy dog. She enjoys dancing around her food bowl one minute and then jumping onto the couch to cuddle with her humans the

next. Lucky follows Lisa around the house and watches her every move. Lucky knows which shoes Lisa wears to work and will go lay on her bed if Lisa puts them on. If Lisa puts on her walking shoes, Lucky will go dance next to the leash hook. She's a smart dog, if you couldn't tell already! She's also known for snorting like a pig when her dog and human friends walk by the house.

Lisa enlisted the help of local dog trainer John Flores to help with Lucky's training so she would be comfortable in her new home. Lisa and John bonded over their mutual goal to educate others about dogs and quickly became friends. Around this same time, Lisa's friend Darlene reached out to her to start a humane education program for children with her. Darlene knew Lisa would be the right person to develop the curriculum because of her educational experience.

Lisa decided to take a leave of absence from teaching full-time to create the curriculum. She was inspired by her experience with and her love for Lucky. Once complete, the program was officially named Lucky Dog Humane Education. Lucky Dog's mission is to encourage children to feel empathy and compassion for people, animals, and all living creatures. Lucky's story is the first unit in the curriculum, and it teaches children to solve problems and keep their pets for life so more animals don't end up in shelters.

Research has shown that educating children from an early age to get connected with their community and empathize with humans and animals can significantly decrease the risk of bully-like tendencies. Lucky Dog helps to build sympathetic leaders who advocate for human rights, animal rights, and a healthy atmosphere.

John's organization, I Pitty the Bull, was the first organization to adopt the curriculum. I Pitty the Bull is dedicated to providing education about responsible pet ownership, the benefits of spay and neuter practices, and improving communication between dogs and humans. John and Lisa often teach together when schools request a presentation by Lucky Dog Humane Education. If allowed by the school, Lucky attends the presentations with Lisa. She loves children and happily drops and rolls over for tummy rubs when she meets kids for the first time.

Not only did Lisa rescue Lucky, but Lucky also rescued Lisa. She was becoming a workaholic, but when Lucky came along, she taught her to slow down. Lisa needed to be present for Lucky because of her needs. She showed Lisa what was really important in life and taught her to work through her problems. Lucky also led Lisa to some of her best friends, including John. If Lucky hadn't come into her life, Lisa would not have left her teaching job to pursue humane education. Because of Lucky and the humans behind Lucky Dog Humane Education, children all over California are learning the importance of empathizing with others and getting involved in their communities.

I'm With Charlie

Love Always Wins

CHARLIE

Charlie captured the attention of Northeast, Ohio, and the nation in 2017. In January of that year, a woman named Jennifer visited a Cleveland-area shelter looking to adopt. She laid her eyes on a sad-looking ten-week-old puppy named Reptar and spent some time playing with him outside of the kennel. When she inquired about Reptar, she found out he was on hold; someone was returning the next day to adopt him.

With her heart still set on Reptar, Jennifer returned the next day to see if he was still there. He was, but was with a man at the front counter getting ready to go to his new home. Jennifer was disappointed and decided to hold off on her search for a new dog that day.

She returned to the shelter a week later to meet other dogs available for adoption, and to her surprise, Reptar had been returned! She took him home that evening and renamed the pit bull–looking puppy, Charlie.

Jennifer and her family lived in Lakewood, Ohio. In 2008, Lakewood City Council voted 6-1 to institute a "pit bull" ban. All dogs more than 50 percent American Staffordshire terrier became illegal to own within the city limits.

After reviewing a photo of Charlie, the City of Lakewood permitted Jennifer to keep him. He was a typical puppy: affectionate, happy, rambunctious. That June, Jennifer made a mistake that would forever change Lakewood, Ohio: She forgot to secure her driveway gate and Charlie escaped. A good Samaritan found Charlie and

turned him into the city's animal shelter. When Jennifer arrived to pick him up, she was told that because Charlie looked like a pit bull, a hearing would be arranged to determine whether he could continue to live in Lakewood.

But, wait. He was approved to live there months earlier, right? Right.

Thanks to a concerted social media campaign, the word about Charlie's plight started to spread throughout Lakewood, and a collaborative effort to end the city's ban on pit bulls began. "I'm with Charlie" signs began to pop up in hundreds of Lakewood front yards. Even people that resided outside of Lakewood and in other states were buying them. An online store that sold "I'm with Charlie" shirts was created. They were worn proudly by humans and dogs alike.

Local and national media began to take notice. About one hundred protesters stood outside city hall at Jennifer and Charlie's first hearing. Days later, Lakewood ruled in favor of the ban determining that Charlie must leave the city within thirty days.

Jennifer and Charlie refused to give up, and so did their supporters. Not only did Charlie have a majority of the city's residents and people around the country on his side, but he also had a stellar law team led by Phil Calabrese (see "Toby" on page 177). Charlie was being represented by the lawyer who had recently won an Ohio Supreme Court case in the Fifth District (which Lakewood is not part of), determining that restrictions and bans of dogs based solely on looks were unconstitutional.

The push to end the discriminatory ban and implement stronger breed neutral laws coupled with safety and education programs waged on. The thirty-day deadline passed and Charlie remained in Lakewood thanks to an appeal to the city's ruling. Not only did residents continue to pack council meetings and protest, but they also showed up to the polls in November, helping to vote two council members out and vote in two pro-Charlie/anti–pit bull ban council members.

City leaders began to grow tired, realizing that the residents weren't going to give up. On April 2, 2018, with a vote of 7–0 in an auditorium overflowing with people and being watched on television and social media by thousands around the country, Lakewood City Council repealed the ban and implemented stronger and more objective breed-neutral laws.

In August of 2018, just a few months after the pit bull ban was officially repealed, Jennifer and her family visited the same shelter Charlie came from to see some puppies that had recently been taken in. They adopted a ten-week-old puppy and named her Hazel. Hazel and Charlie are best friends. She can often be found sleeping on him and licking his face. As it turns out, Charlie's happy ending was only the beginning.

"About one hundred protesters stood outside city hall at Jennifer and Charlie's first hearing."

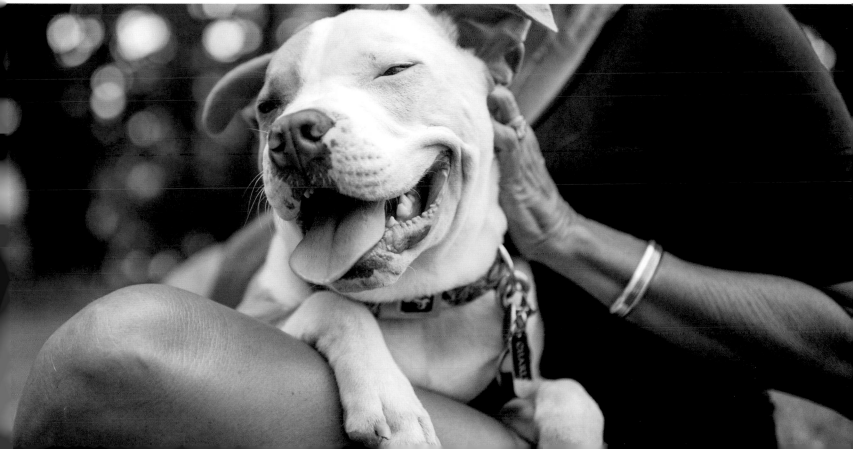

VALENTINA

In 2009, Carla and Allen welcomed Valentina the rescue puppy into their Lakewood, Ohio, home. Because of the pit bull ban the city had adopted a year earlier, they found a dog to adopt with a DNA test completed by the rescue organization. The results stated Valentina was a mix of Boston terrier, English bulldog, and saluki.

As Valentina grew older, she began to look more and more like a pit bull because of her blocky head, but her looks never concerned her family.

When Valentina was about eight months old, she and her dog sibling, Gix, got out of the backyard when a meter reader entered their yard and didn't lock the gate behind him. Lakewood Animal Control was called and, along with Carla, began searching for the two dogs. Within an hour, Valentina and Gix were spotted walking back toward their home. They were safe! They ran to Carla when they saw her, and she quickly secured them in the backyard.

As the two were running toward Carla, the animal control officer saw them and told Carla that Valentina looked like a pit bull and was illegal in Lakewood.

Three days later, Carla and Allen received a letter from the city stating they were "harboring a pit bull" and had two choices: They could get a blood-drawn DNA test at the city's established vet to prove Valentina wasn't a pit bull or move her out of the city. Carla and Allen chose the DNA test, which came with the following results: 50 percent American Staffordshire terrier ("pit bull"), 25 percent boxer, 25 percent

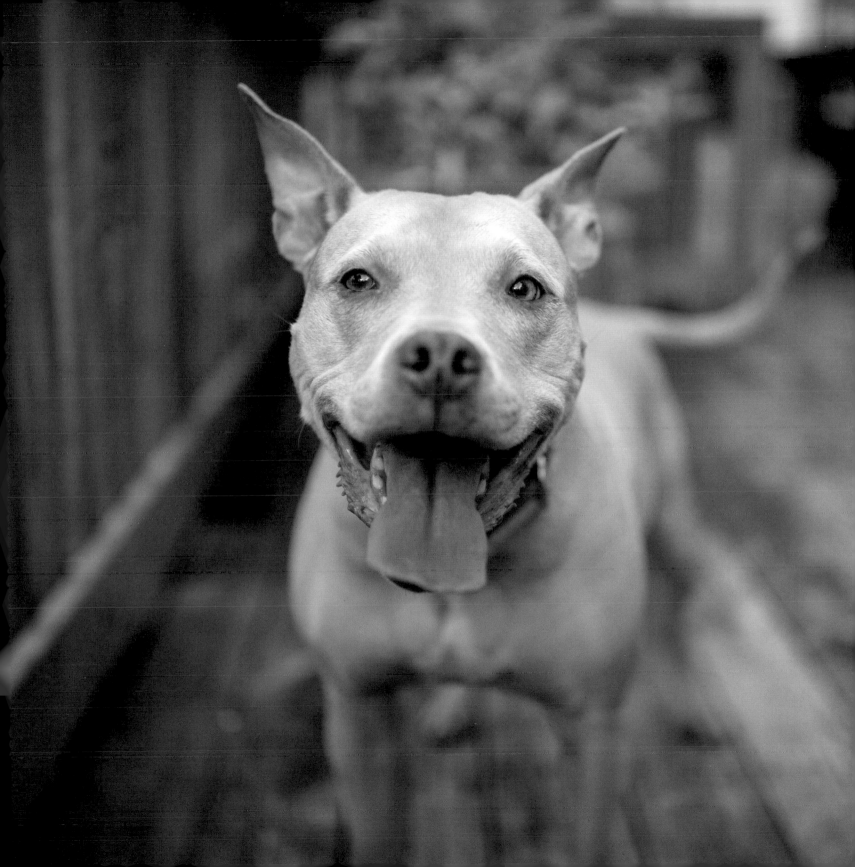

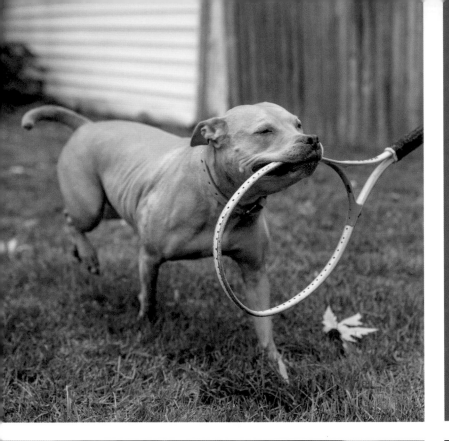

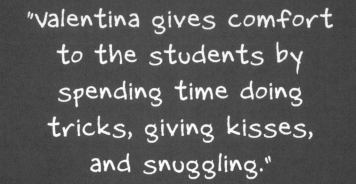

"valentina gives comfort to the students by spending time doing tricks, giving kisses, and snuggling."

VALENTINA

English bulldog. (It was later discovered that the DNA test conducted in 2009 by Valentina's rescue organization did not include American Staffordshire terrier so that municipalities couldn't use the results as a way to discriminate.)

Carla and Allen hired an attorney to fight for Valentina's right to stay in Lakewood, and Valentina moved in with family friends outside of Lakewood for the duration of the suit. At that time, Lakewood stipulated that even 1 percent of "pit bull" DNA was illegal, and there was no formal hearing process to protest a decision.

While giving Valentina up permanently was never an option for Carla and Allen, leaving the city where they bought their first home was—but they weren't leaving without a fight. Because of similar cases going on at the same time as Valentina's, the City of Lakewood more clearly defined what "majority pit bull" meant under the law. Going forward, dogs more than 50 percent "pit bull" would be banned from Lakewood. Because of this, Valentina was allowed to return to her home after being away for three months. Had the DNA results shown even 51 percent American Staffordshire terrier, she would not have been allowed back.

When Valentina was cleared to come back home, it was important for Carla and Allen to show everyone that she was a star. Lakewood called her a pit bull, so they decided to share her wonderful spirit as a pit bull ambassador. Valentina quickly earned her AKC Canine Good Citizen certification and then became a registered therapy dog. She has participated in multiple forms of therapy work by spending time at nursing homes, doctor's offices, and helping with crisis response.

Valentina has always enjoyed being around children. In 2017, Carla began taking her to Lakewood's only high school, LHS. Once a week, Carla and Valentina go to LHS to spend time in a classroom of teenagers with varying needs and skill sets. The kids and staff light up each time they visit the school. Valentina gives comfort to the students by spending time doing tricks, giving kisses, and snuggling. Valentina is funny, spunky, intuitive, loving, and blissfully happy all the time, making her an excellent fit for therapy work. She's a support system for teenagers and has become a best friend to them. In February 2018, the students made her Valentine's Day cards. She has been welcomed and adored at the only public high school in the very city that attempted to expel her years earlier.

MERYL

Fifty-one pit bull–type dogs were seized from the property of disgraced former-NFL player Michael Vick on April 25, 2007. Police had gone to his house with a drug warrant and found a large dogfighting operation hidden behind his home in a large wooded area. Many people and organizations, including the Humane Society of the United States, did not believe that rehabilitation of the fighting dogs was possible and pushed for them to be euthanized. The judge presiding over the case appointed Valparaiso Law School professor Rebecca Huss to represent the dogs' interests during the legal proceedings. After being present during the behavioral assessments of the dogs, Huss recommended that the forty-seven surviving dogs be placed with eight different organizations throughout the United States, including Best Friends Animal Sanctuary in Kanab, Utah.

There is a reason these dogs are referred to as "Vicktory" dogs. Many of the forty-seven went on to earn their Canine Good Citizen certificate and live with families across the country. Some of them became therapy and service dogs. Out of the twenty-two dogs sent to Best Friends, three were court ordered to live their lives out at the sanctuary. One of them was Meryl. Her behavioral assessments determined that she was too aggressive to be adopted out to a family.

That wasn't all bad news for Meryl. The sanctuary, home to about 1,600 animals, sits on more than 35,000 acres within the stunning red rock canyons of southwest Utah.

MERYL

Best Friends is run by hundreds of dedicated staff and volunteers whose primary goal is to give the animals in their care the best quality of life possible. Meryl would be in excellent hands.

Meryl has great dog skills and earned the nickname "Mama" from her caregivers since she is a leader among the dogs. Because she has such excellent leash manners around other dogs, Meryl is a model for other pups lacking those skills. Her calm and relaxed character puts the other dogs at ease, and they no longer react when passing dogs on their leash.

Meryl's days are busy with activities and relaxation time. After breakfast, if the weather is nice, she heads out to her square agility platform or plops down in the sand to sunbathe. After she rests for a bit, it's time to head out for daily activities with her caregivers. Meryl loves walking the various trails on the sanctuary and enjoys taking golf cart and car rides on the sanctuary grounds. When not on walks, she can be found successfully completing many of the obstacles in the agility yard. Once in a while, Meryl spends some quiet time with a former caregiver in an office nearby.

There are several people at the sanctuary that Meryl has come to be comfortable around and love. Now that she's older, Meryl has become much easier to introduce to new people. An introduction is made by having the new person toss treats to Meryl while she is being walked by a current caregiver. After a walk or two doing this, she'll accept the new person into her circle of friends. According to Tierney, one of her caregivers, "Once you become a friend of hers, you are a friend forever."

After her previous run mate Buddy Arnold passed away, a new run mate named Conan moved in with Meryl in 2018. They enjoy lounging around in their dog run together and occasionally get into short wrestling matches with each other. When they go on walks, Conan often stops and lays down in the shade while Meryl continues on her way. When they reunite in the run, the two are always happy to see each other.

Every morning Meryl greets her caregiver with a wagging tail and a cute smile with a tiny underbite. At her age, Meryl seems to enjoy her daily routine of run time, walks, and golf cart rides. While the court order not to be adopted may have seemed like a bad thing at the time, Meryl is a happy dog. She is home and with family at Best Friends Animal Sanctuary. She is safe.

"meryl has great dog skills and earned the nickname 'mama' from her caregivers since she is a leader among the dogs."

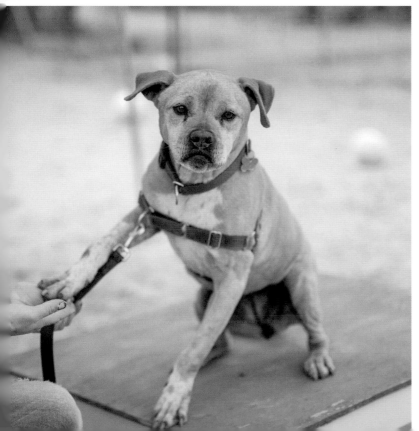

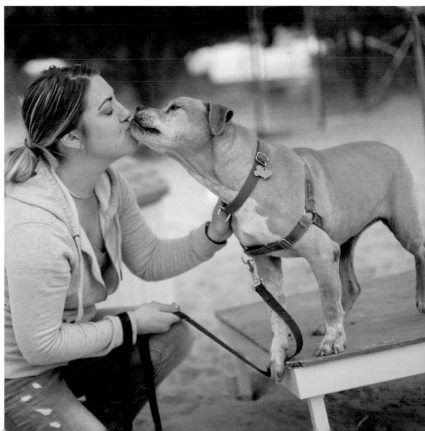

ABEL

A dog named Chief was taken from his owner because of neglect in June of 2012. He was covered in blood and had bites from the owner's other dog, but when Chief arrived at the Cleveland Kennel, he was sweet and calm. He allowed the staff to clean him up and take care of his injuries. The charges against his owner were eventually dropped, but Chief was left at the kennel.

At the same time, a woman named Julie was looking for a calm, balanced male dog to add to her pack of rescues. She saw that Chief was happy and at ease even while in a stressful environment at the city kennel. He was also friendly with other dogs and good with people. Julie adopted Chief in June 2012 and named him Abel after a character from the television show *Sons of Anarchy*.

Given his calm disposition, Julie knew that Abel would make a great therapy dog. He earned his Canine Good Citizen certification and became a registered therapy dog the following year. Abel began his therapy work by visiting schools as part of a pit bull awareness program through Badges for Bullies, a Cleveland-based organization that seeks to strengthen the relationship between area police, the animal rescue community, and the public. Abel also began visiting a nursing home to provide comfort to the father of one of Julie's coworkers.

Julie is a teacher at Lakewood High School in Lakewood, Ohio. But because of the city's pit bull ban, she wasn't comfortable taking Abel to the school with her until the

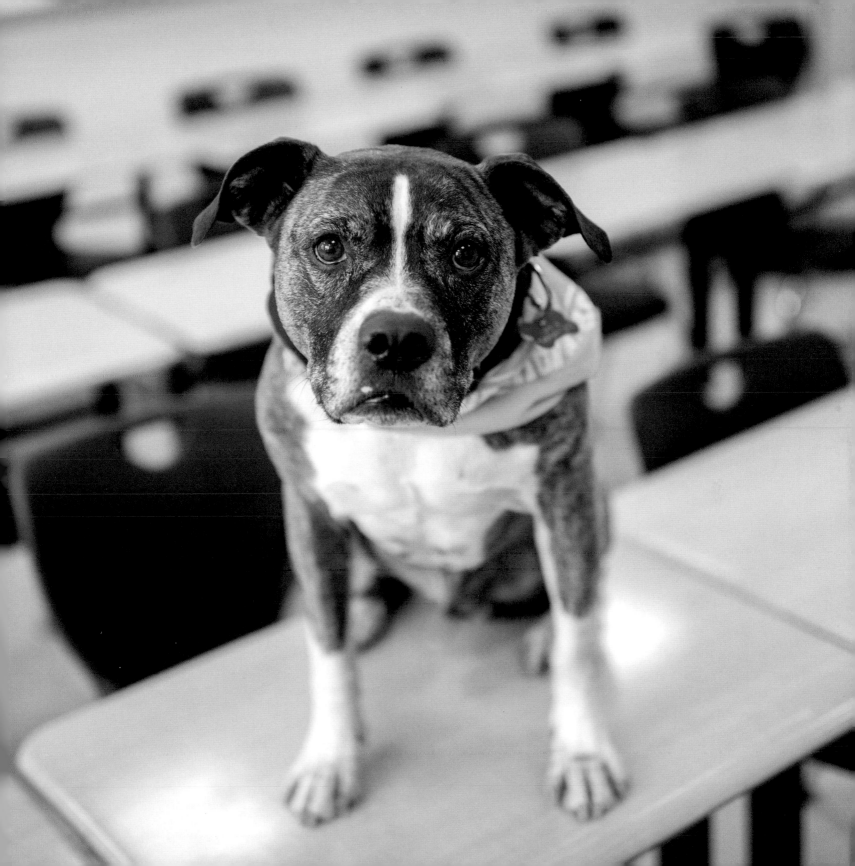

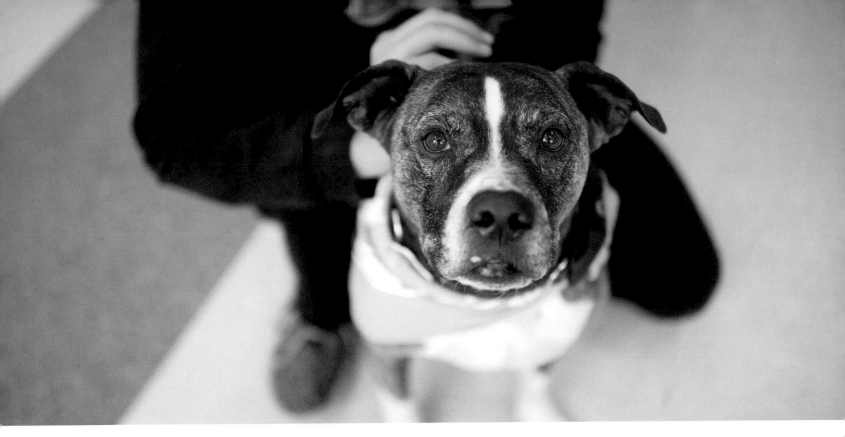

"several students have
told Julie that Abel was
their first friend at
Lakewood High School."

ABEL

ban's repeal on April 2, 2018. Julie brought him to the school for the first time that same month in his official capacity as a therapy dog for the students. Abel is not a shy dog and had no issue establishing himself as an integral part of the high school right away.

Abel now comes to school with Julie almost every day. He greets students with a wagging tail as they enter the classroom, and then quickly rolls over for belly rubs. He frequently cuddles with students throughout class time. Abel is a friend to everyone at the school, even those that are not Julie's students. High school can be a difficult place for many, especially for first-year students. Abel has a welcoming character that makes the students feel comfortable and safe around him.

Several students have told Julie that Abel was their first friend at Lakewood High School. Many have earned the privilege of doing their work with Abel during class. The students like to sit by him, get cuddles, and pet him while they get work done. A couple of students have earned the privilege of taking him outside for a walk on the school grounds.

Abel even attends the high school yoga club meetings with Julie. He often wanders from yoga mat to yoga mat, greeting each student as they move through their poses. During Savasana, the final resting pose of class where everyone lays down on their back and relaxes, Abel can be found resting on his mat, too. Julie has never met another dog like him. She and Abel have developed a powerful bond over the years because they spend almost every hour of every day together. She enjoys watching him interact with her students and witnessing the joy on their faces in their response to him. Abel has a natural way of creating a sense of comfort for Julie, and for everyone around him.

ZOEY

The staff at the Berea Animal Shelter realized that something was wrong with Zoey soon after she was dropped off as a stray in 2014. She was out of control and didn't react to any commands or noises. Amy, the trainer at the time, assessed Zoey on her first day and it became apparent to her that Zoey couldn't hear.

To confirm her assessment, Amy took Zoey to a veterinarian for a Brainstem Auditory Evoked Response (BAER) test to be conducted. The BAER test is used to evaluate the hearing ability of a dog by detecting, recording, and creating a display of the electrical activity of the brain in response to an auditory stimulus. The test confirmed what Amy suspected: Zoey was deaf.

Amy quickly began working on sign language and basic training with Zoey. Putting her up for adoption right away would have set up Zoey and her new family for failure. Amy wanted to ensure that when Zoey found a new home, it would be her home for the rest of her life. It wouldn't be easy. Not only were pit bulls less desirable as a misunderstood type of dog, a deaf pit bull would be even more challenging to adopt out. Zoey's new owners would need to be patient and understanding people.

In April 2015, after six months at the shelter, Zoey was ready for adoption and a Cleveland-area news website reported on her as part of their "Needs a Home" feature. The story caught the attention of a woman named Courtney. Courtney's five-year-old son, Mike, was born deaf but can now hear very well with the help of two

cochlear implants. She sympathized with Zoey, wondering if she would ever find a home in light of her deafness.

Thinking that it could be good for Mike to have a friend similar to him, Courtney took him and her mother to meet Zoey at the shelter. Meeting three strangers was a bit overwhelming for Zoey—she was very hyper and over-excited during their visit and so Courtney and Mike went home without adopting her. Still intrigued by Zoey, Courtney went back two more times by herself to visit her and noticed that Zoey was much more relaxed and focused with only one person present. She decided it was time for a trial run away from the stresses of the shelter and brought Zoey home that February. It became clear that Zoey was a good match for them and within days, she was adopted and became a permanent member of their family.

It was an adjustment for Courtney to have a deaf dog in the home. Getting Zoey to come back inside from the yard was difficult and waking her up wasn't easy either. They would either tap her or hit the floor to make it vibrate a bit so that she would open her eyes. Although it was challenging at times, Courtney and Mike were happy to have Zoey. Mike often said, "Zoey is like me, Mommy."

When Mike and Zoey aren't cuddling on the couch or floor, they can often be found playing and chasing each other in the backyard. Zoey enjoys car rides, peanut butter, watching cars from a chair on the back patio, and meeting new people. She can also be a bit nosy and often follows Courtney around to find out what she's doing. Once she has inspected Courtney, Zoey finds Mike. She likes to know what her humans are up to and joins in whenever she can.

"Not only were pit bulls less desirable as a misunderstood type of dog, a deaf pit bull would be even more challenging to adopt out."

GEMMA

CLEVELAND

Gemma's story began in 2016 when the overcrowded Cleveland Kennel was given the opportunity to transfer some of their dogs to the Longmont Humane Shelter in Longmont, Colorado.

The chief of the Cleveland Kennel immediately put out a call to volunteers to see who, if anyone, would be willing to drive more than one dozen dogs the 1,300 miles to Longmont. Beth jumped at the opportunity. She had started volunteering with the city kennel the previous year after her rescued dachshund passed away. Beth wasn't ready to adopt another dog but wanted to be around them as much as possible. She chose the Cleveland Kennel even though the stereotypes about pit bulls (the most common mix at the shelter) made her a little afraid of them. After her first day of volunteering, Beth quickly realized they were just dogs and didn't deserve the stereotype that some people label them with.

That June, the kennel's transport van was loaded up with thirteen pit bull mixes of various sizes and colors. A sweet and quiet dog named Flo Jo was placed in a bottom crate. When Beth and the other volunteer realized that the final dog was too large to fit in the last remaining crate, they had to pull one of the dogs out and allow it to ride up front. Flo Jo was calmly laying in her crate while other dogs were barking loudly, so it was an easy decision to choose her to ride shotgun. She curled up, went to sleep for the 1,300 mile ride, and was dropped off in Colorado with the other twelve dogs.

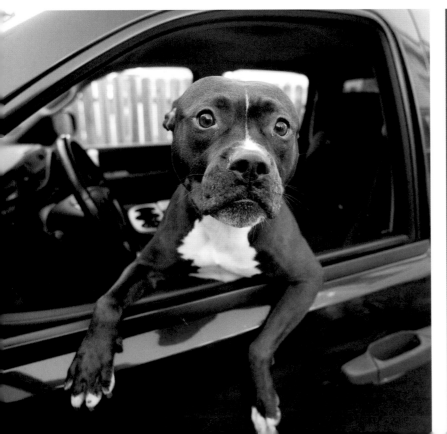

"Gemma helped Beth realize that pit bulls are just dogs and deserve a safe and loving home, just like any other dog."

GEMMA

As Beth and the other volunteer made their way back to Cleveland, they both talked about how much they missed their travel buddy, Flo Jo. Beth couldn't stop thinking about her when she got home. Keep in mind, she had no intention of adopting a dog before her trip to Colorado.

Beth's husband, Bob, was out of town for a work conference in Las Vegas and the Fourth of July weekend was approaching. Beth texted and called him dozens of times to let him know that their dog was in Colorado. After much discussion, full of tears and doubt, Bob finally responded with: "I'm going to get her!" As his coworkers were flying home for the holiday, Bob changed his flight to Denver, rented a car, and drove to Longmont to adopt this dog he had never met. He spent the next two days driving 1,300 miles to bring Flo Jo home.

Flo Jo was renamed Gemma because to Beth, she was a gem. Gemma had to learn to be a dog. She didn't know how to play with toys, walk on a leash, or sleep on the couch without rolling over and falling off. With time, all these things became natural to Gemma thanks to the love that Beth and Bob gave her.

Gemma loves people, especially children. When they are out on walks and she sees a child, Gemma army crawls toward them and flips on her back for a belly rub. Most children are able to see past the fact that she's a pit bull and are happy to give Gemma the belly rub she's seeking. She also enjoys randomly plopping down on walks whenever and wherever she pleases. The attention-seeking Gemma once had to be carried home because she wouldn't get back up off of the sidewalk.

Gemma helped Beth realize that pit bulls are just dogs and deserve a safe and loving home, just like any other dog. Gemma has inspired her to stand up and fight breed-specific legislation in her hometown, and has motivated her to volunteer, advocate, and educate others more than Beth ever planned to do when she began volunteering a year earlier. Beth has since made four trips to Longmont for the Cleveland Kennel, transporting more than fifty dogs to find their forever homes.

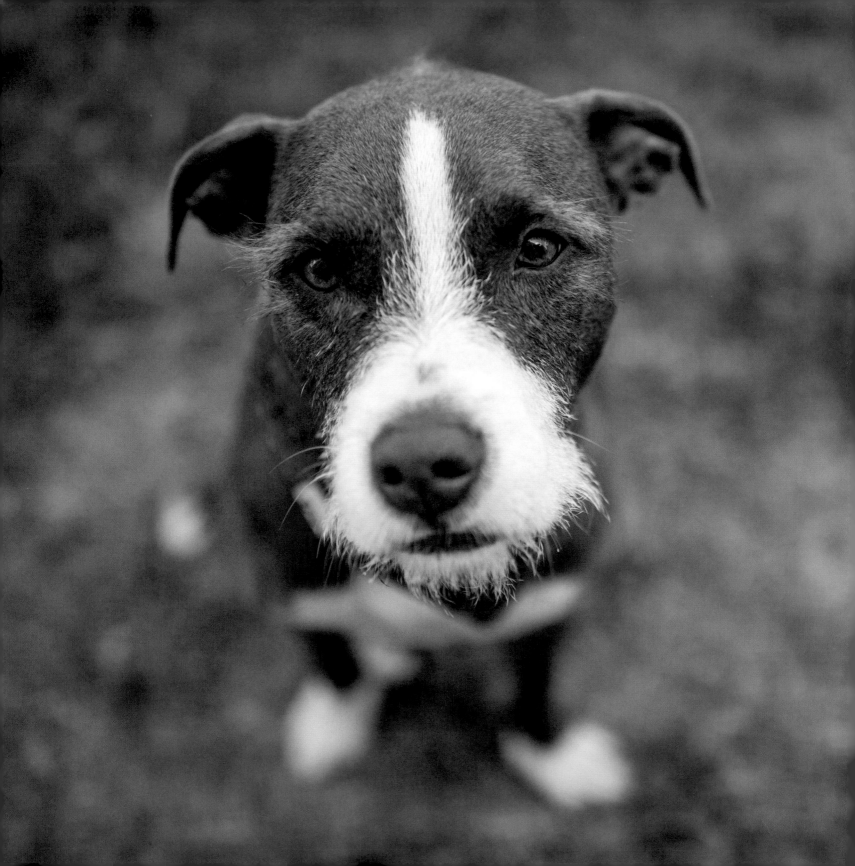

OWEN

A litter of three unique-looking puppies was surrendered at a Long Beach, California, animal shelter in the spring of 2014. The pit bull/wire fox terrier mixes were taken in by Jimi's Angels rescue which partners with Bark n' Bitches, Los Angeles's first humane pet shop, to find permanent homes for rescued dogs.

A few months later, Janet, a preschool director, stopped by Bark n' Bitches and couldn't resist adopting the unique looking puppy that she ended up naming Owen. He spent the first year and a half of his life at the preschool where Janet served as director. She took him to work with her every day, and the children loved his company!

It's quite common for littermates to be adopted by different humans and never see each other again, particularly when they end up in various shelters. That's not what happened to Owen and his brother and sister. The siblings live reasonably close to each other, so the three wirehaired pit bulls still meet up occasionally for play dates.

Because of his wiry hair, Owen challenges many people's expectations of what a "typical" pit bull dog looks like. He also has unique characteristics. For example: farts scare Owen. If a human or another dog farts, Owen will run to the other side of the room. Janet has even witnessed Owen fart, stare at his own butt, and then run away. Besides farts, Owen is also not a fan of windshield wipers. Whenever he hears a noise he doesn't like, his eyes go wide and he snuggles against Janet or the couch for comfort.

OWEN

When he was a puppy, Janet and others would carry him like a baby to calm him down when he was nervous. That routine didn't stop when Owen grew up. When he gets anxious, Owen is likely to find solace in someone's lap or being carried around like a baby. It's his favorite position to be in.

Janet eventually left her preschool job and opened up a doggy daycare and boarding facility in downtown Los Angeles where Owen spends his days and helps out. He and his best friend, Rocco the pit bull rescue (see "Rocco" on page 156), are two of the four "evaluation dogs" at the facility. All new dogs who are registered at the daycare spend time with Owen and Rocco as part of their evaluation to determine whether off-leash group play is a good fit for them. Owen is exceptional when introduced to new dogs.

Every time Owen and Rocco see each other (which is almost every day), they act like they're reuniting after being apart for years. Sometimes they react that way after being apart for only thirty minutes. Owen and Rocco eat and drink from the same bowl, sleep cuddled up next to each other, wrestle together, and play tug-of-war with toys. When not helping with dog evaluations, they're often welcoming humans and dogs or relaxing in the front lobby of the daycare.

Owen loves to go on hikes with Janet and other dogs in the mountains that surround Los Angeles. Janet describes Owen as the "caboose" during the hikes because he wanders slowly behind the group. When not on pack walks with his dog friends and their humans, Owen enjoys making new friends at the local dog beach.

Owen is a kind and loving dog who can be quite anxious at times. All dogs are unique, and he's a great example, especially when it comes to his appearance. While the phrase *pit bull* is a general term used to describe multiple breeds, most pit bull–type dogs are just mutts like Owen and have many different looks.

"Because of his wiry hair, Owen challenges many people's expectations of what a 'typical' pit bull dog looks like."

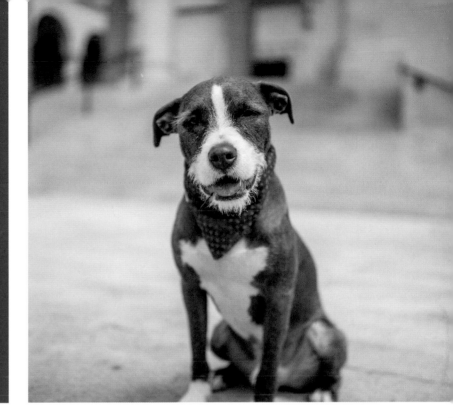

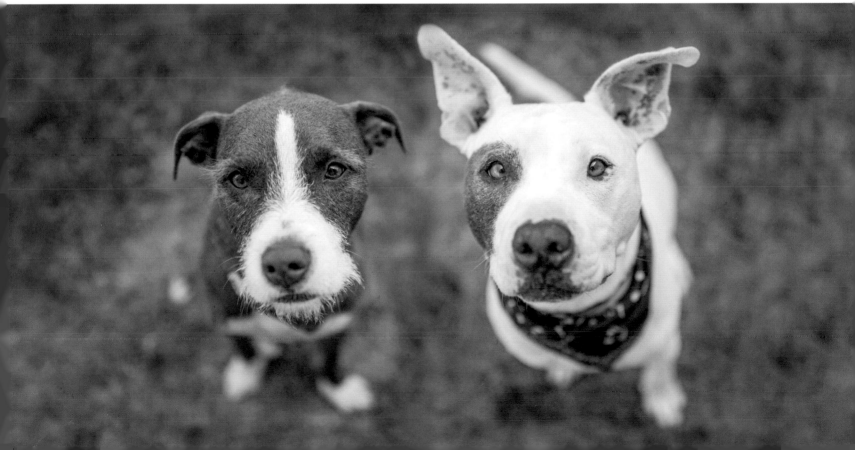

ROCCO

Rocco was picked up as a stray puppy wandering the streets of Oceanside, California, in 2010. When he was taken to the San Diego Humane Society (SDHS) to be put up for adoption, his evaluation showed that he was a very low maintenance and submissive dog. This made him a great mascot for other rescue dogs while at the shelter. SDHS took Rocco to visit elementary schools that summer and used him as an example to share about all the work the shelter does.

Around the same time, Lisa was moving into a new home by herself and wanted a companion with whom to start this new chapter of her life. She visited SDHS and came upon Rocco. The black patch over his eye immediately caught her attention. The volunteer dog handler told her that Rocco was great with other dogs, children, and cats. This was a perfect fit for Lisa because she lived steps from a dog park and her family owned a children's daycare that she often visited. Rocco now had a forever home and Lisa had the companion she sought.

In January 2016, Lisa was making connections on social media with people involved in Southern California animal rescue when she was introduced to Janet and Owen (see "Owen" on page 153). Lisa messaged Janet to see if she wanted to meet at a dog park to have a playdate between Owen and Rocco. The four quickly became friends and began meeting up a couple times a month. Later, Janet asked Lisa to

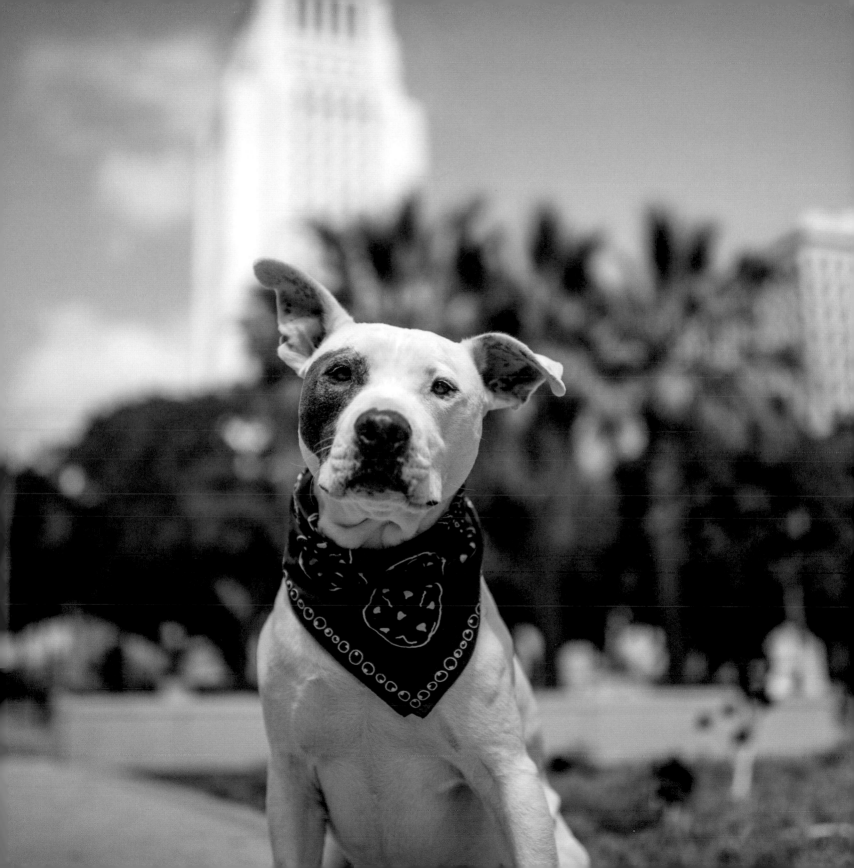

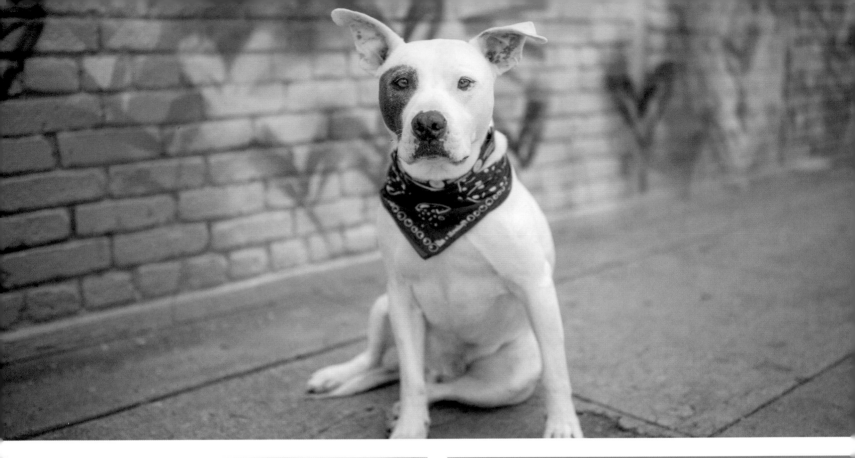

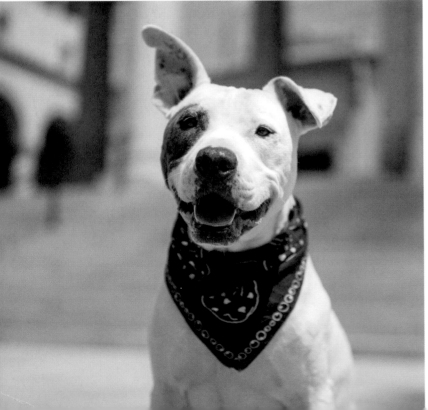

"Rocco loves walking past the local delicatessen in downtown San Diego because he knows the owner will always greet him with a piece of sandwich meat."

ROCCO

move to Los Angeles to help open up her new dog daycare and boarding facility in downtown LA. Lisa and Rocco said yes!

Along with Owen, Rocco is an evaluation dog at the daycare and boarding facility. Rocco meets every dog that comes through their doors to test if a cage-free environment is right for their temperament. Rocco participates in nearly all evaluations at the facility. If it so happens that there are no dogs to meet that day, he gets the day off. Rocco is very friendly with all dogs. He has some dogs he plays with more often than not but when given the choice, he prefers to either be playing with Owen or sunbathing.

Rocco is a very relaxed dog. He sleeps and dreams a lot. Lisa has been told by several veterinarians that Rocco has one of the slowest and most rhythmically consistent heartbeats they've ever heard. Rocco can be very nosy when visiting homes for the first time and enjoys exploring kitchens. His favorite place to play is Fiesta Island, a beachside off-leash dog park near Lisa's parents' home in San Diego. Rocco loves walking past the local delicatessen in downtown San Diego because he knows the owner will always greet him with a piece of sandwich meat. He has also discovered that all the valet attendants in San Diego have dog treats in their booths so he makes it a point to always stop and say hello to them.

Rocco has a four-year-old rescued brother named Andy, a dachshund-terrier mix also from the San Diego Humane Society. Andy cherishes Rocco and Rocco secretly loves Andy. Lisa describes Rocco as the social butterfly and Andy as the irritating little brother who is always tagging along.

Rocco regularly senses when Lisa needs him. He nudges her to step away from her computer when she needs a break. He will sit and lean right next to her if he knows that Lisa is not having a good day. Rocco is Lisa's favorite thing to see when she walks through the door, and he always greets her as if he is seeing her for the first time in a very long time, even if it's only been a moment.

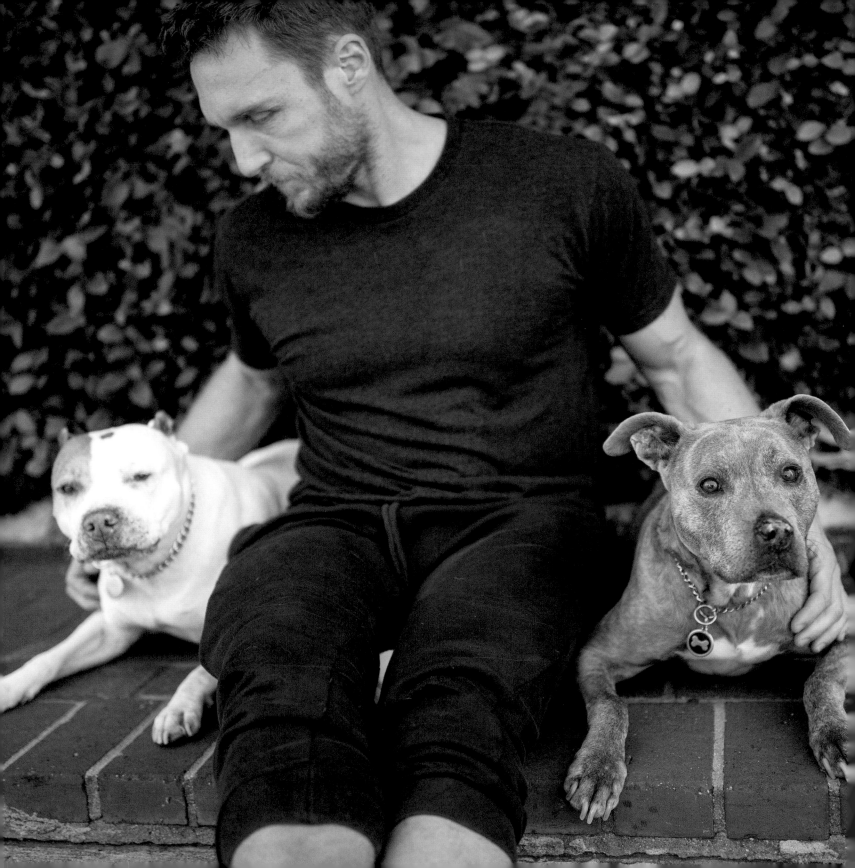

TRENT & ELLA

The beginning of Ella's life was far from easy. She was part of a dogfighting opera-
tion and was used to breed puppies. When rescued, Ella had bite marks all over her
face, mange on her muzzle, and burn marks from the chain that prevented her from
escaping. Luckily for her, she was rescued out of that situation, and her forever human
came along in 2010. Jason, a gym owner and trainer in the Los Angeles area, adopted
Ella after meeting her through a friend who was fostering her.

Jason decided it would be best to invest in rehabilitation and training for Ella given
her difficult upbringing. While at the training facility, Ella met a gray and white dog
named Trent. Trent, found as a stray, had been rescued by Ella's dog trainer, Lynn, not
long before the two dogs met. Trent and Ella immediately connected at the facility,
and it soon became evident that they would be inseparable. When Jason saw the two
together interacting at the facility for the first time, he noticed how happy they were.
Jason and Lynn both agreed that Ella and Trent belonged together. Once training for
Ella was complete, both she and Trent went home, together, with Jason.

Ella and Trent spend many of their days at Jason's gym. Friends and clients often
stop by to say hello to the dogs even if they don't have an appointment. Sometimes
visitors also lay down in the dog beds with Trent and Ella. It's not uncommon for
Jason's clients to delay their workouts because they want to spend time with his
dogs. While much of their time is spent in Jason's gym office, they sometimes come

out to the floor to greet clients; Trent and Ella are smart and know to stay out of peoples' way while they complete their workouts.

Once Ella approached Jason during a client session, and he told her to go lay down because he was busy working. She proceeded to walk back toward her bed but stopped in the middle of the gym to relieve herself. All everyone there could do was laugh. She was trying to tell Jason she needed to go outside, and he didn't listen. Lesson learned, Jason! Sometimes Ella and Trent have what Jason refers to as "pit fits." They squirm like crazy on their backs and make funny noises whether at home or on the gym floor.

The two dogs get along with everyone. Ella is the social butterfly and loves other dogs, children, and adults. Trent is skeptical of others at first, but once he decides he approves of a person, it's like he's known them his whole life. Everyone who meets the two tend to melt because of how loving and friendly they are.

Ella and Trent have helped change the minds of hundreds of people when it comes to the stereotype of pit bull–type dogs. Because of Jason's career as a trainer, Trent and Ella have become friends with some of Hollywood's most well-known celebrities. Not only has their own human appeared in movies, but many of Jason's clients are also actors, and they enjoy sharing their love for Ella and Trent with their millions of social media followers and fans. Ella and Trent can cast a large net when it comes to sharing how amazing they are! And Jason makes sure to let everyone know how beautiful they are every chance he gets.

Ella and Trent came from difficult backgrounds. Hurt and abandoned, they had every reason to be skeptical of humans. They opened their hearts and became happy, loved by many, and influential to thousands around the world.

LEONARD

A one-year-old stray pit bull was picked up off the streets in October 2016 and taken to a nearby shelter in Marysville, Ohio. Jim, the shelter director, quickly realized that they would have a difficult time adopting out this dog they named Leonard. He had a very high possessive drive: Leonard wanted to have just about everything that anyone was carrying: wallets, balls, keys, toys . . . he wanted them all. That excitement for objects can often be mistaken for aggressiveness and would have made it very difficult for him to live in a regular home. Possessiveness drive is, however, an excellent characteristic for a very specific task for dogs.

Jim had been training police dogs for more than twenty years and saw Leonard's potential to become a successful police narcotics dog. Narcotics dogs need to have a strong possessiveness drive. If Jim threw a ball into the woods, Leonard wouldn't come back until the ball was found. With the proper training, the need to work, play, and possess objects could be directed into the skill of sniffing out specific odors and receiving a ball as a reward.

When Jim met Leonard, Clay Township, Ohio, happened to be searching for their first K9 narcotics dog. During the search, the police chief got in touch with the training facility that had just finished training Leonard. Not only was Leonard ready, but he was also being given away for no charge because he was a rescue, and not purchased or imported from Europe. The only money invested by the township was for the chief's training with Leonard.

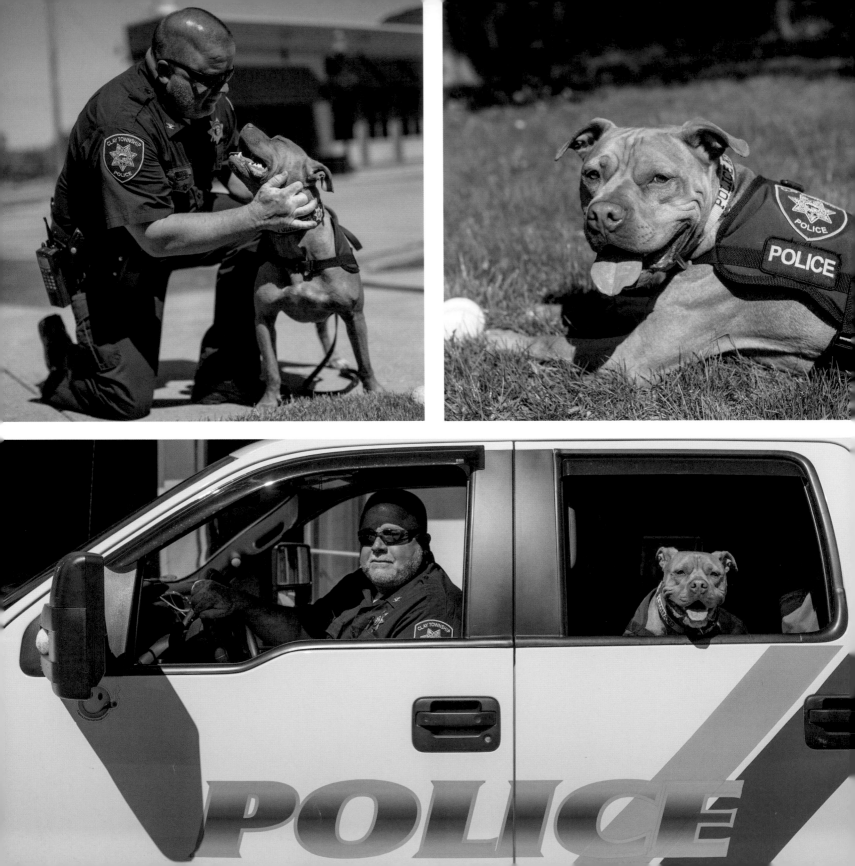

LEONARD

Leonard and the chief worked together on a daily basis for about four weeks at the training facility. At that point, Leonard was already prepared to detect narcotics. This was their time to get to know each other and it was the chief's opportunity to observe and note Leonard's distinct behavioral change when Leonard smelled narcotics. When Leonard scents narcotics, he slows down and becomes more methodical in his search. He then sits and stares at the location where he detects the drugs. Leonard and the chief passed their certification in May 2017 and went to work the following day.

Leonard doesn't have an off switch. He's energetic, playful, and lovable according to Chief Mitchell. He can be ready to start the day at 2:00 a.m. When Leonard is on a narcotics call, he gets very excited when he spots the flashing lights of other police cars on the scene. He understands that he's about to go to work and can hardly contain himself.

A few hours after a weekday call, Leonard can often be found hanging out with the children at the local elementary school where the teachers and students love him. When they arrive in the school parking lot, Leonard wags his tail in excitement before he and Chief Mitchell start roaming the hallways.

Given that Leonard is one of the only narcotics dogs in the area, the chief and he are on call 24/7 to help other municipalities near Clay Township. If Chief Mitchell is at work, Leonard is with him. Whether in their truck, police headquarters, or out on a call, they are always together. Leonard is part of the police force and is treated as such.

Leonard is also a respected member of the community. The residents of Clay Township have been overwhelmingly accepting of him. They adore Leonard and he adores them. Leonard can often be found attending community events such as fundraisers, school fairs and carnivals, meet and greets, and more. While not the reason the department brought Leonard in, Chief Mitchell believes Leonard's connection with the residents has helped to bring the community and police department closer together.

SUKA

At only eight weeks old, Suka was brought to a shelter by the Akron Police Department after she was seen being tossed from a moving car. Because her injuries (including two fractured elbows) would have been too expensive for the shelter to treat, Suka was scheduled to be euthanized. Her life was saved when a veterinarian at the animal hospital used his own time and money to rebuild both of Suka's elbows.

The vet adopted Suka and brought her home to his family. Unfortunately, she spent too much time in her kennel while with this family and began to develop aggression issues.

After a few years, the family decided that Suka should be returned to the animal hospital.

Christine, an employee at the same veterinary hospital, was going through her own personal struggles when she met Suka. Suka stuck out to her. Christine viewed Suka's struggles as a product of her less than ideal environment in her previous home, and she could relate to that. Suka had been set up to fail with no exercise and stuck in a kennel all day with little mental stimulation. One day Christine overheard the vet saying he didn't know what else to do with "this dog" because she was just too much for anyone to handle. Christine knelt to Suka's level and offered her a treat and almost lost a nose because of how eager Suka was to take it! At that moment, Christine saw Suka's potential and sensed that none of the aggression issues were her fault. She

was anxious, pent up, and needed an outlet—the perfect project for Christine to focus on. Christine knew Suka could be a good dog if she was given a fair chance. She adopted Suka in 2015.

Christine began working with Suka immediately and noticed a quick improvement. Suka spent less time in her kennel, more time outside, and got more interaction with humans. Christine wanted Suka to be a great ambassador for pit bull-type dogs so in 2017, they began Canine Good Citizen and therapy dog training. Suka passed with flying colors in April 2018. Christine is currently working with her to become a service dog.

As part of her therapy dog classes, Christine enrolled Suka in a library program in Akron, Ohio, where children practice reading to her. Reading to dogs often helps children build their confidence. Some children are scared of Suka at first because she is a pit bull-type dog, but once they see how warm and calm Suka is, they dote on her. They enjoy trying to make her crooked ear go back to "normal."

Whether it be zoomies, flips, or playing with her rescued pit bull siblings, Tessa and Newman, Suka loves to run and be active. She has her feeding spot memorized and if Christine asks her "Are you hungry?" she runs and waits for her food in that exact spot. She also loves hide-and-seek under blankets, playing with squeaking toys, and snuggling under the covers.

Suka and her siblings have helped save Christine's life as she has navigated difficult life situations. Everywhere Suka goes, people are shocked by how well behaved she is in spite of being a "pit bull." Christine has grown more confident in herself just by working with Suka through their challenges. Suka is a support not only to Christine, but also to others who might suffer from anxiety and depression. Suka has taught Christine what it means to be truly self-less and to forgive. Because of Suka, the only type of dog Christine will ever adopt will be pit bull-type dogs.

BAXTER BEAN

Deirdre Franklin, founder and president of Pinups for Pitbulls (PFPB), began fostering Baxter Bean from a New Jersey–based rescue organization when he was about five months old. He had been badly burned by either fire or an acid-like chemical—no one is quite sure what the cause was—and to this day his back and hips are covered by scars. As a puppy, Baxter was deeply afraid of everything. He hated to be alone and, unlike most dogs, was not food motivated. He challenged Deirdre to adapt to a new way of dog training. Regardless, she knew she could give Baxter the life he deserved and quickly decided to adopt him in 2006.

Baxter is Deirdre's second pit bull rescue. When she adopted her first dog, Deirdre hadn't been looking for a pit bull–type dog. She didn't have any experiences with pit bulls, and her dream dog at the time was actually a husky. Deirdre's love of pit bulls began when she was nineteen and volunteering at a Philadelphia-area animal refuge. Sadly, the refuge would euthanize surrendered pit bulls simply because they viewed them as a "risk." Deirdre once did her best to adopt a pit bull who had been brought in by a woman who found the dog on the street; she did everything in her power to get that dog out of the refuge and adopt it herself, but with no luck. Not long after this experience, Deirdre adopted a pit bull from a different rescue organization and named her Carla Lou. Years later, Deirdre would sit down with a board member from the Philadelphia animal refuge and help them overturn their policy

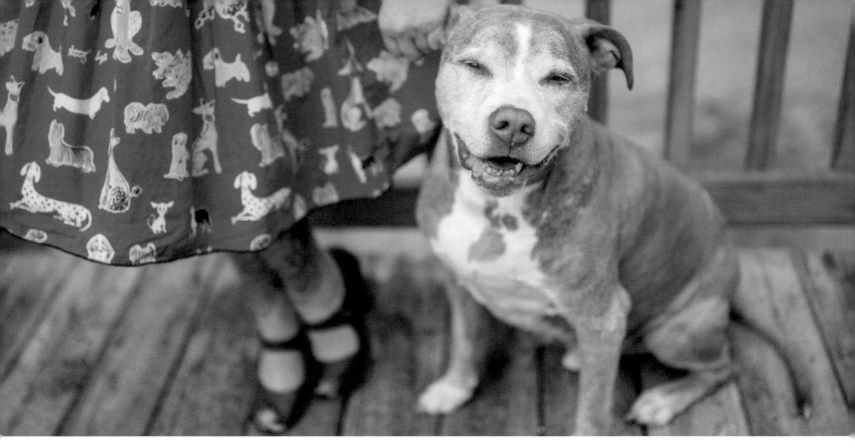
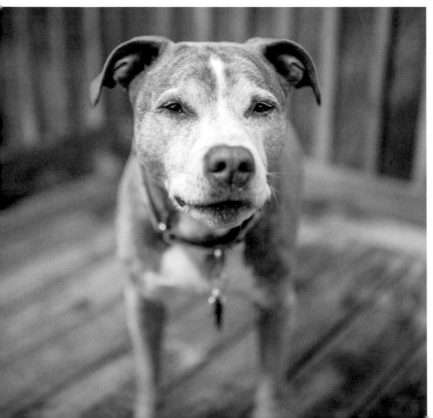
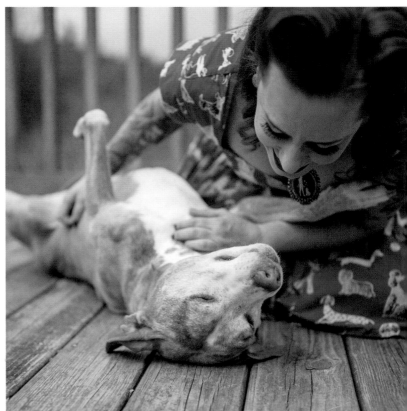

of euthanizing pit bulls. Her calling to make a difference in the lives of pit bulls had become clear, and she's been advocating for the misunderstood dogs ever since.

Baxter has taught Deirdre patience and has helped her become a better critical thinker since he does not operate like most dogs. His needs are simple but very particular: Baxter enjoys being home and on his porch, soaking up the sun and chasing lizards. He likes being out on the open road and enjoys sticking his head out of rolled down car windows in order to smell the world around him. Even after the severe abuse he endured prior to his coming into Deirdre's life, he now loves and trusts her.

Baxter is very food motivated now that trust has been firmly set in his life. His favorite treats are dried out codfish skins. According to Deirdre, you could get him to do your taxes if you persuaded him with a skin. Baxter also loves cookies, belly rubs, butt scratches, and being told how handsome he is. He knows when you need to laugh and when you need to be sat upon. Baxter can clear a room with his toots, and he may or may not be proud of that skill.

Deirdre's nonprofit, Pinups for Pitbulls, was established in 2005, and is one of the country's most well-known pit bull–centric organizations that advocates for the blocky-headed dogs. Deirdre started PFPB once she returned home to Pennsylvania after deploying with the Humane Society of the United States for Hurricane Katrina disaster relief efforts. Concerned for all the pit bulls left behind and breed-specific legislation being reinstated in cities like Denver, Colorado, she wanted to make a big impact. Deirdre sought out a photographer to help her make a calendar. Baxter has been part of every Pinups for Pitbulls calendar since 2008. Every year the calendar features twelve pinup models and twelve rescued pit bulls from around the country, and is used to help promote pit bulls as the "lovable goofballs" Deirdre knows them to be.

TOBY

One summer day in 2011, Becky and her daughter Sophie stopped by a Cleveland area animal shelter to donate leftover cat food. Sophie asked her mom if she could look at the dogs available for adoption—they had been considering getting a companion for their rescue dog, Hermes, whom they adopted a year earlier. A quiet brindle dog quickly made eye contact with nine-year-old Sophie while she was viewing the kennels. Sophie remembers him being cute and standing out from the other dogs because he was the only one not barking. They took Toby back to their Shaker Heights, Ohio, home that day.

Not long after adopting Toby, and knowing the difference their family had made in his life by providing him a home, Becky decided she wanted to give her time back to rescue animals by volunteering. It started with walking dogs four to five days a week at the Cuyahoga County Animal Shelter (CCAS). Soon she was spending ten hours a week running playgroups for the dogs. Becky went on to become president of Friends of CCAS where she has helped to raise fifty thousand dollars through fundraising events for the shelter in just two years.

In early 2014, a push to implement a pit bull ban in their city of Shaker Heights by city officials and residents began. This movement distressed Toby's family and caused them to wonder if Toby would be welcome in their city. Becky and Phil began to attend meetings, along with many other residents, to push back against the proposed ban.

TOBY

They helped to bring in legal and dog experts to speak at council meetings, where the experts debunked myths about pit bull–type dogs and discussed studies that show dog bans do not make cities safer. Becky, Phil, and Shaker Heights residents' tireless efforts paid off, and the push to implement the pit bull ban failed. Common sense and love prevailed in Shaker Heights.

Shaker Heights was only the first pit bull ban fight for Phil, who happens to be a lawyer. In September of 2015, he filed an appeal to challenge the pit bull ban in Reynoldsburg, Ohio, for a client who was told she couldn't keep her pit bull in the city. This was Phil's first professional foray into a legal case involving animal law. He was requested specifically because of his personal involvement fighting the proposed ban in Shaker Heights. On April 24, 2017, the Ohio Fifth District Court of Appeals issued an opinion reversing the trial court's ruling by declaring the Reynoldsburg ordinance unconstitutional. This victory and Phil would go on to play a role in another Ohio city: Lakewood (see "Charlie" on page 129).

During this time, Toby earned his Canine Good Citizen certification. Some certification requirements included sitting calmly while a stranger pets him, walking on a loose lead through a crowd, coming to his handler when called, remaining calm while his handler is out of sight for three minutes, and letting a stranger examine his ears and pick up his feet. Toby passed the test with flying colors.

Toby's favorite thing to do is burrow. He disappears under blankets and sleeps that way for hours at a time. At nine years old, he is placid and morose-looking at times, which can often frustrate his playful sibling, Hermes. The two may be different, but they enjoy each other's company.

Before adopting Toby, Becky and Phil never imagined how involved they would get in pit bull advocacy. The impact Toby had on them has forever changed Lakewood and Reynoldsburg, Ohio, helped to keep Shaker Heights from adopting a ban, and will have a lasting effect on the State of Ohio and rescue dogs everywhere.

"Before adopting Toby, Becky and Phil never imagined how involved they would get in pit bull advocacy."

ANGEL, TODD & SALLY

Todd, Sally, and the Stand Up For Pits Foundation (SUFP) got their start with a pit bull–type dog named Angel. Angel was found in June 2007 running through streets of South Central Los Angeles. Her ears had been horribly cropped, she had chemical burns on her back and puncture wounds on her legs, she was filthy, and she appeared to be have been used as a breeding dog. She spent two months at a South Los Angeles shelter before she was pulled out by a small rescue organization and placed into a foster home with actress and comedian Rebecca Corry.

Rebecca hadn't planned on owning a dog again. Devastated from having lost her dog, Walter, very suddenly to kidney failure, she was only willing to foster. Though no one knew it at the time, Angel had found her forever home in this fortuitous foster placement, and would set Rebecca on a trajectory that would change her life, and many others', for the better.

Rebecca adopted Angel in July 2008 and became keenly aware of the fear-based ignorance people expressed toward Angel. Strangers would cross the street when they were out on walks and people told Rebecca that Angel was dangerous and would "turn" on her. Outraged, Rebecca decided she could be a voice for Angel and mislabeled dogs just like her. She began producing live comedy shows whose ticket sales would benefit pit bull–type dog rescue organizations in Los Angeles. The first Stand Up For Pits event was held in 2010. In 2013, Rebecca filed the requisite paperwork to become a nonprofit, and Stand Up For Pits Foundation, Inc. was born.

The Stand Up For Pits Foundation (www.standupforpits.us) is dedicated to educating, advocating, and saving the lives of pit bulls. Every year since 2010, SUFP

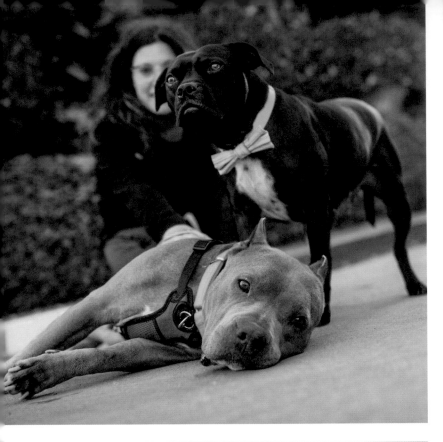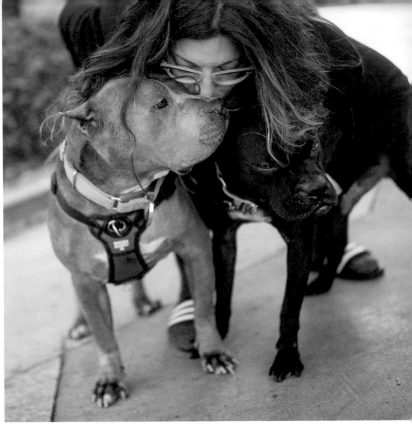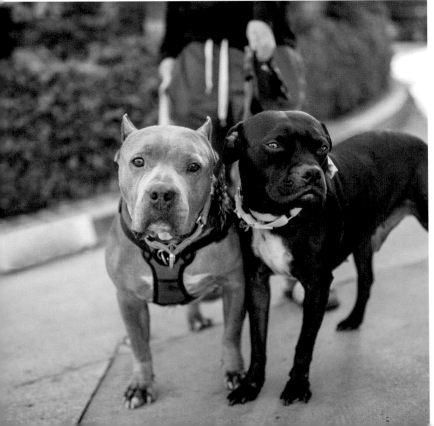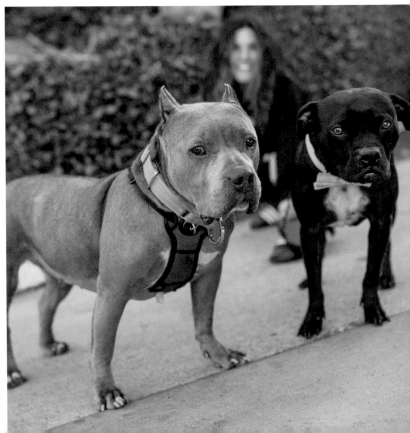

invites rescue organizations around the country to participate in their events. Each stand up comedy event includes a SUFP donation drive, which raises thousands of dollars worth of shelter supplies. Funds are raised through ticket sales, donations, silent auctions, and merchandise sales. Many dogs have been placed in loving forever homes because of these events.

Their advocacy didn't stop with stand up: Rebecca and Angel went on to lead thousands through the streets of Washington, DC, in the One Million Pibble March in 2014 to raise awareness about dogfighting and the discrimination many pit bulls experience.

Angel passed in 2016, but her spirit and legacy lives on. Because of Angel and the nonprofit organization she inspired, hundreds of thousands of dollars have been raised, countless dogs' lives have been saved, and many minds have been changed. Rebecca's experience with and love for Angel has paved the way for two other dogs, or "velvet unicorns" as Rebecca likes to refer to them, to enter her life: Todd and Sally.

Todd was rescued from a dogfighting ring in 2016. Two dogs from the operation were taken in by SUFP: Todd, and his mother, Lucille. Todd was the only survivor after Lucille passed and the others were euthanized. Rebecca adopted Todd in 2017 and not long after, SUFP rescued a dog named Sally on death row at a Los Angeles shelter. She was overbred and had clearly suffered severe abuse and neglect at the hands of terrible people. Together, Todd

and Rebecca fostered Sally while she waited to find her forever home.

Sally was diagnosed with mast cell cancer, a malignant form of cancer, and also required additional treatment for many other health issues. Rebecca decided she would adopt Sally herself. Rebecca and Todd are committed to giving Sally the life she deserves.

Todd and Sally are best friends—each with their own silly quirks. They love cuddling on the couch together, often in very awkward positions. Rebecca sometimes calls them "couch potato farting clowns." They are inseparable and feel safe with each other. During walks, Sally often plops down on the sidewalk without warning to relax or wiggle around on her back. Todd is known for his silly facial expressions and looks practically human at times. He often has a very straight face that says, "I don't give a damn."

Out of curiosity, Rebecca ordered DNA tests for both Todd and Sally. Todd's results were English bulldog and Staffordshire; Sally's results were French mastiff and Staffordshire. But like most dogs labeled pit bull–type dogs, they are mutts. "Pit bull" is a term used to describe a type of dog based solely on appearance.

Angel changed the trajectory of Rebecca Corry's life. Sally, Todd, and countless others are alive because Angel lived and her life and legacy continue on in all the amazing work the Stand Up For Pits Foundation does. Angel is, as Rebecca calls her, magic.

DIESEL

Ana and Brian were ready to add a four-legged member to their family in 2013. The two spent a lot of time in the outdoors and wanted a hiking buddy to join them on their adventures. Brian was set on adopting a pit bull-type dog. He was well aware of all the negative stereotypes and wanted to help save a blocky-headed dog from being unnecessarily euthanized. As luck would have it, a friend reached out to them to let Brian and Ana know that he knew of someone trying to find a new home for his pit bull. If a home wasn't found, the owner would surrender his dog to the shelter.

Ana and Brian went to meet the dog named Diesel and immediately noticed that the man had Diesel locked up in a small wire kennel. As soon as he opened it, Diesel flew out of the kennel and ran straight to Ana and Brian, covering their faces in kisses. It was as if he knew the two were there to get him out. Ana and Brian both looked at each other and, without a word, knew what the other was thinking: we need to take him home. Diesel was incredibly underweight and looked severely neglected.

The first night at their home, ten-month-old Diesel couldn't sit or lay down because he was in so much pain from the wire kennel he'd been previously locked up in that lacked any padding or flooring. But that was all in the past now that Diesel was in his forever home.

Diesel quickly went to work when it came to changing minds about pit bull-type dogs. Ana's mother had a negative stereotype about pit bulls because of the negative

news stories she often saw on television and the adverse and false comments that came from a famous television judge. When her mother met Diesel, she was a little hesitant at first but he quickly won her over with his bubbly and loving personality. She is now a big advocate for pit bulls and helps educate others who have false stereotypes about them.

Diesel's health hit a major road bump in 2017. He had a large amount of fluid in his chest and was diagnosed with the rare illness called a chylothorax. Ana and Brian feared they were going to lose their best friend. The extensive surgery that needed to be done immediately would cost thousands of dollars that they didn't have after already spending six thousand dollars just getting to the diagnosis. They needed another ten thousand to cover the cost of surgery.

Ana's mother suggested she start a GoFundMe campaign for Diesel. At first Ana was vehemently opposed to the idea and felt embarrassed to have to ask others for money. She thought about it for a few days and decided

crowdfunding his medical bills might be their only option. In less than two weeks, more than eight thousand dollars was raised thanks to Diesel's tens of thousands of followers around the world! Diesel's surgery was successful, and he quickly went back to being the goofy and healthy dog he had been.

Diesel loves snacking on ice cubes and enjoys playing with boxes and anything that is stuffed. He especially enjoys hiking, swimming, and snuggling with his humans. Diesel has many silly quirks—he doesn't approve of Ana and Brian using their laptops; he will come up from behind the screen and push it down with his nose. Diesel is an expert at pouting when he doesn't get what he wants and can win over Ana's mother, getting what he wants 100 percent of the time. He protects his family from the vacuum by quietly running up behind them and pushing it out of their hands. Once the vacuum is turned off, Diesel barks at it until it's put away.

It's imperative for Ana and Brian to share Diesel with the world to show everyone that he's just a dog, an extraordinary dog.

MALIBU

In early 2015, one-year-old Malibu found herself at a boarding facility with her stay being paid for by a rescue organization that was running out of money. When the organization shut down, it would have left Malibu without a home but the boarding facility kindly agreed to let Malibu stay at no cost.

At the same time, Christine started volunteering with dogs at the boarding facility who were waiting for a foster or forever home. She had seen a video about Malibu on social media and wanted to help out. The video showed Malibu trying to squeeze her head and her paw through the bars of the kennel, which broke Christine's heart. She decided to make it her mission to get Malibu adopted into a forever home. She began walking her regularly, working on commands, and socializing Malibu with other dogs and humans. Christine was quickly drawn in by Malibu's eyes, ears, and smile.

On July 1, 2015, the boarding facility informed Christine that Malibu needed to be removed from her kennel so they would have room for the dogs of paying clients who were going out of town for the Fourth of July holiday. At this point, Malibu had been at the facility for four months while being visited and trained by Christine every Friday. Christine agreed to foster Malibu and took her home that day. The two had connected so well over the previous months that Christine knew Malibu had found her forever home, with her, that evening. The adoption was finalized a month later.

MALIBU

When Christine and Malibu began going on walks around her neighborhood together, she noticed that most people who saw Malibu seemed to avoid them, presumably because she was a pit bull–type dog. People would cross the street, owners of small dogs would pick them up off of the ground, and parents would move their children out of the way while watching Malibu closely as they passed. They were once asked to leave the premises of an area they enjoyed walking in because pit bull–type dogs were not allowed. This was very upsetting for Christine; she knew Malibu was a kind and warm dog who didn't deserve to be discriminated against. People had no reason to judge her and so Christine decided to do something about it.

Christine began putting a colorful bandanna on Malibu before taking her out on her walks. The results were immediate. Most people stopped avoiding them and some even mentioned how cute Malibu was. Just like that, she wasn't dangerous in the eyes of complete strangers. She was just a dog. For people who were still a bit nervous, but comfortable enough to approach Malibu, it was an opportunity for Christine to educate them about pit bull–type dogs.

Malibu now has a collection of more than one hundred bandannas that she wears. In 2018, Christine opened up an online store where she sells a variety of handmade bandannas for dogs. A percentage of the sales go to a different rescue organization each month. Malibu's story was even picked up by local and national media outlets. This has allowed Christine and Malibu to use her fame and social media following to help promote animal rescue and fight discrimination against pit bull–type dogs.

Malibu's favorite activities are car rides and nature hikes. When Christine takes a bandanna out of the drawer, Malibu immediately bumps her nose on her leash and then proceeds to sit by the garage door. She also enjoys trips to the mountains, lying in the sun, staring at trees blowing in the wind, and napping on the couch or patio. While Malibu enjoys just about all food, she especially loves fish treats, blueberries, watermelon, and mango. Most of all, she enjoys being an ambassador for pit bulls by helping to educate others and ending negative stereotypes.

TIPS TO HELP END BREED-DISCRIMINATORY LEGISLATION

The amount of work required to end discrimination against dogs where you live will vary. It isn't easy and takes a lot of time, patience, and hard work. You get what you put in when it comes to improving laws and making change on a governmental level. Here are some tips based on my experience helping to end breed-discriminatory laws in my hometown of Lakewood, Ohio, in 2018. Some of these tips may not apply to you depending on the amount of resistance you are getting from city leaders. Some tips may prove to be invaluable.

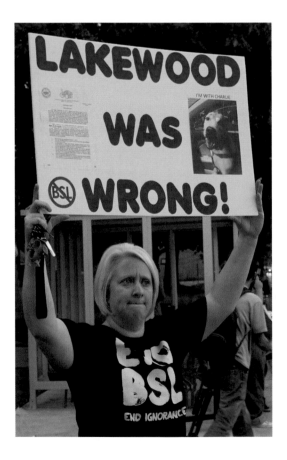

WRITE TO OR MEET WITH YOUR LEADERS

Find out what their stance is on the current legislation affecting dogs that look a certain way. If they support breed discrimination, find out why and use that information to your advantage. Maybe they rely on false information, or they had a bad experience with a dog in the past. It's an opportunity to provide them with factual resources, debunk myths, and find out about the experience that shapes their opinion. In some cases, I've found that leaders were unaware that their city had any form of breed discrimination and were quick to remove it from the law.

RALLY A LARGE NUMBER OF RESIDENTS BEHIND THE CAUSE

This is the most important in my opinion. The more residents involved, the better. It says a lot when 99 percent of the residents packing city council meetings are there to end breed discrimination

and 1 percent is there to support keeping it. Often, zero pro-discrimination residents attended our meetings in Lakewood. In the words of Lakewood Councilman Dan O'Malley after the vote to end discrimination in Lakewood on April 2, 2018, "You can pretend to care, but you can't pretend to show up."

ATTEND COUNCIL MEETINGS ON A MONTHLY BASIS

Be seen and be heard. The more you go, the more you get noticed. If you go consistently and don't give up, city leaders will know that this isn't a short-term push to end the discriminatory legislation. The city will be forced to address the issue and make their stance public. Our goal in Lakewood was to make this a part of every city council meeting. By doing this, we forced it on the official agenda and eventually got them to have a vote on the issue.

FOCUS ON THE IMPORTANCE OF SAFETY AND STRENGTHENING LAWS

Safety is the number one priority. Your push to end discrimination isn't just about dogs with blocky heads. It's about breed discrimination not working to make cities safer. It's about this form of legislation creating a false sense of safety, and not focusing on real objective laws that are proven to equate to safety. While your goal is for all dogs to be recognized equally, the leaders that you're speaking to have safety on their mind. You can show them all the photos you want of children with pit bull–type dogs, but it won't make a difference.

Breed-discriminatory legislation is highly subjective and relies on someone's opinion when identifying a dog. We all see things differently. Subjective laws have no business being part of any government. Effective, objective, and robust breed-neutral laws do. Objective

laws are easily enforceable and don't impact certain types of dogs based on looks. They affect all dogs and hold all owners accountable when enforced. When the ban ended in Lakewood, the city implemented much more effective and stronger laws. Our city no longer has breed discrimination and we're safer.

REQUEST PUBLIC RECORDS

This is one of my favorites, and we found it to be invaluable in our fight to end breed discrimination in Lakewood, Ohio. There is a lot of helpful information that can be found via public records requests. Start broad by asking for all emails between city officials over the past few years with the word "pit bull" or "dog ban" in them. Do you know about a dog that was kicked out of the city for being or looking like a pit bull? Find all the correspondences related to the case. Often you will find damaging information that will help your case to end the discriminatory legislation.

Request dog bite reports and statistics. The records often show that all types of dogs are causing injuries to residents. If your city doesn't keep track, then how do they know the discriminatory legislation is working? In most cities, correspondence between city employees and police or animal control records is public to residents.

BRING IN THE EXPERTS

Share studies and prominent organizations' stances on breed discrimination. Did you know that there are no reputable organizations that support breed discrimination? In fact, the Centers for Disease Control and Prevention, American Bar Association, American Kennel Club, American Society for the Prevention of Cruelty to Animals (ASPCA), American Veterinary Medical Association, Humane Society of the United States, and

many more do not support breed-discriminatory laws.

Invite professionals and experts that work with all different types of dogs to attend city meetings. Reach out to other cities that repealed breed-discrimination laws and invite their leaders to speak about their positive experience with repealing the laws.

For cities with breed discrimination, it is highly likely that their animal control officers were trained by the National Animal Care and Control Association (NACA). Did you know that the NACA is against breed discrimination and even addresses the difficulties of dog identification in their training? Use this info to your advantage.

Bring breed identification studies to meetings or send them to your city leaders. Pit bull–type dogs come in all shapes, sizes, and colors. They're difficult to identify and there are many studies that show this. Dogs are often misidentified by experts, so imagine how often they're being misidentified by police, residents, and animal control officers.

UTILIZE SOCIAL MEDIA

Spread the word about your fight to end breed discrimination where you live by creating a group page. Create Facebook events for each council meeting you are going to to maximize the attendance. The more people that show up, the better. Large crowds in support of repealing the legislation make a statement and grab the attention of the leaders and local media.

Share stories online. In Lakewood, we made slideshow videos to share specific instances of the discriminatory laws not working. For instance, Lakewood approved a dog based on looks that DNA tested at 87 percent American Staffordshire terrier (pit bull). They approved the very dog they deemed dangerous to live in the city. Time and time again, we found cases of misidentification by our animal control department.

We also shared the story of a woman that was visiting Lakewood with her pit bull–type dog. She was on a dog-friendly patio, patronizing a restaurant with her well-behaved dog. Animal control arrived after being alerted by a meter reader and kicked the well-behaved dog out of the city based on its looks. This is not the message you want to send to visitors spending money in your city. Get these stories out. They put pressure on the city to make a change.

VOTE

Our successful push to end breed discrimination in Lakewood started one year prior to city council elections. Three out of seven of our city council members were up for re-election that year. Once we knew who supported the pit bull ban repeal (and who didn't), we went to work campaigning for the anti-discrimination candidates. Two of the three incumbents who supported the pit bull ban were voted out, and we helped vote in two anti-discrimination candidates. This was the first time in more than twenty-five years that an incumbent at-large council member running for re-election was voted out in Lakewood. And we got two out! We needed five of seven council members to vote in favor of repealing the discriminatory legislation, and the election brought us that majority. The vote to repeal ended up being 7-0 because the others on council saw how those who supported the ban were not re-elected.

CHOOSE YOUR WORDS CAREFULLY

Give yourself the right title when you communicate with your city, other residents, and the media. "Pit Bull Advocate" sounds great, but "Safety, Education, and

Anti-Discrimination Advocate" sounds more professional. Plus, you're utilizing the very important word "safety" in your title.

When speaking at meetings or emailing your leaders, it's very easy to get emotional. Many of us are guilty of this, including me. Speak with facts, science, and stories. Avoid getting angry; be professional.

ALERT THE MEDIA

Let as many people as possible know about your cause. Local media is usually very happy to share stories like this. News stations know that breed discrimination can be a divisive topic, so they are happy to share these stories on the news and social media in order to get viewers to tune in or visit their websites.

What mayor or council member wants to be seen by thousands as someone who supports discrimination? What mayor wants to see their city on the news in a negative light? Not many. Getting the media involved is a great way to get breed discrimination on the agenda and possibly force a vote.

BE BETTER

Many pro-breed discrimination advocates only have one method of operation: instilling fear in others while sitting behind a computer.

Get out, show up consistently, be professional, focus on safety, educate others, attack the effectiveness of the laws, vote, and most importantly, never give up.

When it comes to rescue animal and pit bull advocacy, we're not going to agree 100 percent of the time. And that's OK. We learn and grow from disagreement and having different opinions. However, we must not let our disagreements divide us. I see it all too often in the pit bull and rescue animal advocate world. This division keeps us from achieving our mutual goals of ending discrimination, ending animal cruelty, ending dogfighting, and getting every shelter animal into a good home.

Respect one another. Acknowledge that we're not all going to agree on every part of rescue and advocacy. Acknowledge that we all come from different backgrounds and situations that shape who we are. We can't move forward if we fight. But we can move forward if we have constructive and respectful conversations when we disagree. We can't move forward by disrespecting the very advocates that have the same goal as us: ending discrimination.

SAFETY TIPS

We can't be good dog advocates if we do not also preach safety, welfare, and responsible pet ownership. Educating others and raising your pets in a safe and accountable manner are the things that have a direct impact on decreasing dog bites. Since a majority of dog bite incidences involve children, it is imperative that we educate them starting at a very early age. Please consider sharing these safety tips with your children, family, and friends.

- Be kind to pets
- Never tease, harass, or chase a dog
- Do not pull on tails or ears
- Do not reach over or through fences or walls to pet or touch a dog
- Always ask permission before approaching or petting a dog
- Always approach a dog slowly and carefully
- Do not enter a property containing a dog if the dog's human does not accompany you
- Be careful around a mother and her puppies
- Do not assume that a dog wagging its tail is happy and friendly
- When approached by a strange dog, stand quietly, hands at your sides, and avoid eye contact
- Do not approach dogs in cars
- Do not approach dogs that are on chains or ropes
- Do not put your hands or face between two dogs
- Do not take toys away from a dog who is playing with them
- Never bother or interrupt a dog when it is eating
- Always have a leash on your dog when it is not in your home or on fenced property
- Take your dog to your vet for yearly check-ups and required immunizations
- Avoid over-crowded dog parks and consider if a dog park is even the safest environment for your dog based on its personality
- Avoid using retractable/flexi leashes and keep your dog(s) close to you while on walks

Safety was of the utmost importance when creating *Pit Bull Heroes*. For artistic purposes, leashes were often photoshopped out of the photos. For photos where leashes were not used, we were in designated off-leash areas or in fenced areas. There were often multiple people behind the scenes to ensure the safety of the dogs and the people around us.

DOGFIGHTING

Dogfighting continues to be a problem, especially in the United States, and pit bull–type dogs are the most commonly used to fight. There are many ways that you can help to combat this problem.

The Humane Society of the United States offers rewards of up to five thousand dollars for information leading to the conviction of a dogfighter. For more information, please visit www.humanesociety.org.

SIGNS THAT DOGFIGHTING MAY BE OCCURRING

- A large number of poorly socialized pit bull–type dogs chained on a property
- Scared and injured dogs, especially pit bull–type dogs
- Dogfighting equipment: breaking sticks, treadmills, and springpoles
- Fenced or walled-in fighting pits
- Large amounts of vitamins, drugs, and vet supplies

HOW TO COMBAT DOGFIGHTING

- Report it immediately to HSUS, local authorities, and the local media. Call HSUS at 1-877-TIP-HSUS. Your name, number, and personal information will be kept private.
- Contact your local and state officials if your animal cruelty and dogfighting penalties are not sufficient. Encourage them to strengthen penalties for dogfighting and increase funding for enforcement of dogfighting laws.
- Share the HSUS dogfighting video and $5,000 reward poster on social media platforms.
- If you spot dogfighters on any social media platform, take screen shots and gather relevant information, then immediately contact HSUS along with local authorities.
- Educate others using social media.
- Support local rescues and animal shelters and the local media.

All dogs are different. Just because Chango enjoys wearing outfits doesn't mean your dog will. Just because Penni enjoys rappelling off cliffs doesn't mean your dog will. Be careful anytime you try something new with your dog and be willing to accept that they might not enjoy it. Maintain a safe and healthy environment; don't push them past the limits they are willing to accept.

ACKNOWLEDGMENTS

I would like to express my gratitude to the many people that made this book possible and for those who have supported me over the years.

Thank you Kristen, Mom, Dad, Brian, Leo, Kensie, Maria, Brian P., and all my clients, friends, followers, and fellow advocates.

Thank you everyone that allowed me to come into your homes and meet your dogs for this book.

Thank you, dogs, for not giving up on humans, even when some of us have caused you so much pain. Thank you for your forgiveness and for allowing us into your lives.

Best Friends Animal Sanctuary
OPEN 8-5 | VISIT, VOLUNTEER, ADOPT
BESTFRIENDS.ORG

ABOUT THE AUTHOR

Greg Murray is an animal photographer and rescue and pit bull advocate. His first book, *Peanut Butter Dogs,* is a rollicking portrait collection of more than 140 dogs, many of them pit bulls, enjoying peanut butter. Greg lives near Cleveland, Ohio, with his wife, Kristen, and their two rescues: Leo (50 percent pit bull) and Kensie (12 percent pit bull).

@thegregmurray | Greg Murray Photography | www.gmurrayphoto.com

IN MEMORY

There is only one thing I don't like about dogs: they don't live long enough. Selfishly, I wish they would outlive us. Given all the good they bring to the world, they deserve to.

It was only inevitable that during the process of making this book (which started in early 2018), some dogs would pass on between then and the time you are reading this.

To the pit bull heroes we have lost: we love you, we miss you, and we are thankful to have been graced with your presence.